Figures of Thinking: Convergences in Contemporary Cultures

synapses freedom spirituality history belief pulse webs
separation body choice territory poetic future obsession
other feminine impulse text faith diasporas meditation
nation home biography change hybrid experience beauty
global village urban systems associative intimate everyday
displacement maps commonality tactile race convergences
stereotyping migration perception age metaphor testimony
border politics private natural assumption theory process
universal religion sensuality travel intuition ethnic mythology
inclusion colonialism routes commodification representation
culture dislocation physical memory roots nomads literal
local transformation skin place translation morphing roles
psychological dreams absence interventions figurative net
mutation anonymity mask illusive allusive life identity play
conscious ephemeral materiality death unconscious cycles
immaterial culture innocence offerings location allegory
narrative violence nationalism safety norm meditation icons
repetition materials quietude media trade happenings oral
tradition humor satire surrealism bridges information link
boundaries challenge dichotomies time space contemporary
multiple consumerism conditioning coherence coexistence
appropriate appropriation visceral senses refraction portrait
scale plastic piercing shifting storytelling slavery punctures
destination reactive insight differentiation control immersion
conceptual atmosphere evocative mirror disgust blurring
communication definition sensibility undercurrents dialogues
implicit respect avenues interpretation distance possibilities
fragility collage equivocal embedded evaluate interventions
provocative surface superficiality ownership fear symbolism
human subversion mimic question ancestry associations
accents consideration fact fiction comment individuality
rural taboos immigrant clichés acceptance think feel look

Published on the occasion of the exhibition
Figures of Thinking: Convergences in Contemporary Cultures
curated by Vicky A. Clark and Sandhini Poddar
organized and circulated by Pamela Auchincloss/Arts Management, New York

Richard E. Peeler Art Center
DePauw University, Greencastle, Indiana
September 14–December 4, 2005

McDonough Museum of Art
Youngstown State University, Youngstown, Ohio
September 8–November 3, 2006

Tufts University Art Gallery
Aidekman Arts Center, Medford, Massachusetts
January 18–March 25, 2007

Western Gallery
Western Washington University, Bellingham, Washington
April 13–June 9, 2007

Joel and Lila Harnett Museum of Art
University of Richmond Museums, Richmond, Virginia
October 19, 2007–February 10, 2008

synapses freedom spirituality history belief pulse webs
separation body choice territory poetic future obsession
other feminine impulse text faith diasporas meditation
nation home biography change hybrid experience beauty
global village urban systems associative intimate everyday
displacement maps commonality tactile race convergences
stereotyping migration perception age metaphor testimony
border politics private natural assumption theory process
universal religion sensuality travel intuition ethnic mythology
inclusion colonialism routes commodification representation
culture dislocation physical memory roots nomads literal
local transformation skin place translation morphing roles
psychological dreams absence interventions figurative net
mutation anonymity mask illusive allusive life identity play
conscious ephemeral materiality death unconscious cycles
immaterial culture innocence offerings location allegory
narrative violence nationalism safety norm meditation icons
repetition materials quietude media trade happenings oral
tradition humor satire surrealism bridges information link
boundaries challenge dichotomies time space contemporary
multiple consumerism conditioning coherence coexistence
appropriate appropriation visceral senses refraction portrait
scale plastic piercing shifting storytelling slavery punctures
destination reactive insight differentiation control immersion
conceptual atmosphere evocative mirror disgust blurring
communication definition sensibility undercurrents dialogues
implicit respect avenues interpretation distance possibilities
fragility collage equivocal embedded evaluate interventions
provocative surface superficiality ownership fear symbolism
human subversion mimic question ancestry associations
accents consideration fact fiction comment individuality
rural taboos immigrant clichés acceptance think feel look

Figures
of
Thinking:
Convergences
in
Contemporary
Cultures

Vicky A. Clark
Sandhini Poddar

Pamela Auchincloss/Arts Management and University of Richmond Museums

foreword

The University of Richmond Museums is pleased to participate in the organization and presentation of this exhibition of current work by contemporary artists who are raising important questions germane to the world in which we live. *Figures of Thinking: Convergences in Contemporary Cultures* affords us the opportunity to engage audiences in discussions that are critical to the vitality of our pluralistic society and asserts the power of art as a medium for negotiating the concepts of difference and identity, and commonalities despite differences.

The Tucker-Boatwright Festival of the Arts at the University of Richmond offers our university community as well as the greater Richmond region an opportunity to engage in the arts by bringing a special focus through a different academic discipline each year. What could be a more fitting theme for a campus-wide, indeed a city-wide, conversation than what comprises *Figures of Thinking*? Therefore, this exhibition is the core of the 2007–2008 Tucker-Boatwright Festival presented by the University Museums in collaboration with the Department of Art and Art History, immersing our community in discussions of hybridity, national cultural identity, and issues of diaspora and nomadism through an interdisciplinary approach.

The exhibition begins at DePauw University and travels to Youngstown State University, Tufts University, and Western Washington University before arriving at the University of Richmond, and all five universities, as well as other venues, will benefit in untold ways from this profound exhibition curated by Vicky A. Clark and Sandhini Poddar. They have provided our audiences with the visually rich and intriguing works by these artists and have given us a context for experiencing this art and the topics raised. The artists demonstrate the power of art to address concepts of difference and identity in a changing world, and the curators have led us into a meaningful dialogue of these concerns.

Special thanks must go to Vicky A. Clark and Sandhini Poddar for their dedication and vision as curators of the exhibition and for their thoughtful "conversation" essay. Their discussion in this book will spark thousands of conversations on the issues they raise, and we applaud their passion to bring this art to the public's attention. We thank Pamela Auchincloss, who has organized this exhibition, for her foresight

in bringing this project to fruition and for allowing the University Museums to participate in this exhibition from its inception.

At the University of Richmond, our special appreciation goes to Dr. William E. Cooper, President; Dr. June R. Aprille, Provost and Vice President for Academic Affairs; and Dr. Andrew F. Newcomb, Dean of the School of Arts and Sciences, for their continuing guidance and support of the University Museums, comprising the Joel and Lila Harnett Museum of Art, the Joel and Lila Harnett Print Study Center, and the Lora Robins Gallery of Design from Nature. A Tucker-Boatwright Festival committee, chaired by Tanja Softic, Associate Professor of Art, included members from the art history and studio art faculty along with staff members of the museums.

The committee was instrumental in bringing this exhibition to the University; developing the courses, artist's residencies, lectures, events, and other related programming; and involving the campus community through other disciplines and departments, from programs in International Education to performing arts in the Modlin Center for the Arts. We would like to thank the University's Department of Art and Art History and the numerous faculty and staff members responsible for the realization of this project at our University. As always, we acknowledge our appreciation to the staff of the University Museums.

The exhibition and this accompanying publication at the Joel and Lila Harnett Museum of Art of the University of Richmond Museums are made possible in part with the generous support of the Tucker-Boatwright Festival of the Arts, with additional funding from the University's Cultural Affairs Committee and the Louis S. Booth Arts Fund.

Richard Waller
Executive Director
University of Richmond Museums

acknowledgements

We have frequently talked about this exhibition as a dinner party with a group of fabulous friends. In order to pull it off, we relied on many others, all of whom added something to the mix. We would like to thank the artists who accepted our invitation to be in an exhibition that wasn't clearly defined with only a promise to arrange their work in a way to promote a dialogue with the work of other artists. In addition to their work, they offered conversations and insights that enriched the show. What a pleasure it has been.

An exhibition cannot exist without the generosity of those who agree to part with their treasures for a prolonged period, and we are grateful to all of our lenders. Private collectors include Trish Bransten, Stina and Herant Katchadourian, Andre Powe, A.O. Scott and Justine Henning, and Danny Simmons. Institutions include The Arts Council of Ireland, the National Museum of Women in the Arts, and the Peabody Essex Museum. Galleries include George Adams Gallery, Alexander and Bonin, Capsule Gallery, Catharine Clark Gallery, Hauser & Wirth, JHB Gallery, Sara Meltzer Gallery, Newman Popiashvili Gallery, Paradigm Art, and Sikkema, Jenkins & Co.

We relied on the trust, graciousness, and hard work of many others to help with contacts and loans. We thank George Adams, Gregory Amenoff, Georg Bak, Jayne H. Baum, Florian Berktold, Ted Bonin, Jeffrey Chiedo, Catharine Clark, Bill Corbett, Karina Corrigan, Vivian Djen, Oliver Dowling, Kerry Folan, Jason Goodhand, Helena Gorey, Randi Jean Greenberg, Darragh Hogan, Ted James, Paddy Johnson, Christina H. Kang, Dr. Judy L. Larson, Aristides Logothetis, Sara Meltzer, Gregor Muir, Marisa Newman, Molly O'Rourke, Robert S. Peckar, Dr. Rashmi Poddar, Jordana Pomeroy, Irena Popiashvili, Natasha Roje, Claudine Scoville, Teka Selman, David Southard, and Susan Fisher Sterling.

Early on, we talked to Pamela Auchincloss about our ideas, and her enthusiasm, faith, and knowledge were crucial. She, Christopher Saunders, and Kerry Kennedy made everything happen, and we are extremely grateful to our partners. We also want to thank the institutions that are hosting our show: Kaytie Johnson and The Richard E. Peeler Art Center at DePauw University in Greencastle, IN; Leslie Brothers and the McDonough Museum of Art in Youngstown, OH; Amy Schlegel and the Tufts

University Art Gallery, Aidekman Arts Center in Medford, MA; Sarah Clark-Langager and the Western Gallery at Western Washington University in Bellingham, WA; and Richard Waller and Lulan Yu at the Joel and Lila Harnett Museum of Art, University of Richmond Museums in Richmond VA.

We thank the University of Richmond Museums for underwriting this wonderful publication, which will enable the show to live beyond its tour and reach a larger audience. Designer Brett Yasko made the ideas and images come alive with his creative voice. We are indebted to those who made suggestions for our conversation, especially Richard Spear who took the time to ask challenging questions and Joseph Folino Gallo.

While not directly responsible for this exhibition, we would like to acknowledge CUE Art Foundation because it brought us together in the first place. We got to know each other through discussions at the twice-yearly meetings of the curatorial advisory committee. The Virginia Center for the Creative Arts hosted Vicky at a residency in the fall of 2004, giving her time to explore many of the ideas that became a reality in this show. What a gift of freedom, made possible by a grant from the Vira Heinz Endowment in Pittsburgh. Everyone should be so lucky.

VAC/SP

introduction

One of the ways we learn is by differentiating … a cat from a dog, red from blue, humans from chimps, one strain of flu from another, ad infinitum and ad nauseum. In the current atmosphere of increasing and hardening ideas of geopolitical realities, it is easy to separate ourselves by envisioning a world increasingly defined by a series of isms. Even with recent talk of the global village, transit lounges, and hybrids or long-standing academic discussions of simultaneous appearances, it seems as though our brains remain hardwired to perceive differences rather than commonalities. Despite immense differences in backgrounds, experiences, and approaches, the artists selected for this exhibition are all products of the impulse to move: either physically into new environments or through their work that has to do with transformation in some way. They share certain visual and conceptual sensibilities as evidenced by their considered and metaphorical use of materials, willingness to share the intimate and the personal, confrontation of stereotypes, regard for beauty, and immersion in process.

By conceiving an exhibition where multiple points of view yield connections, we attempted to reveal the connective tissue linking contemporary ideas and cultures. Just as synapses firing in the nervous system activate communication, this exhibition offers a conceptual and visual environment where gaps can be broached across apparently disparate work, creating a network of conversations. Moving beyond the cerebral deconstruction and analytic critique of postmodernism, we wanted to see how artists could create meaning in a world that has shifted dramatically in the last five years. Politics and alliances have changed, rhetoric has hardened, and many feel that we are retreating into more stringent categorizations and judgments. Yet we felt a need to avoid the typical curatorial tendency to limit dialogue by categorizing, theorizing, and conceptualizing. Instead, we offer a more personal take and open-ended discussion of issues that affect us. We have, in essence, organized a dinner party for some of the most interesting artists we know and had an enjoyable evening of serious talk, sharing of opinions and stories, and even fun and laughter. In the process, we found a shared interest in several important notions concerning place, identity, politics, belief, thoughts, feelings and memory, all of which emerge from the experiences and issues of our times.

These convergences reference

:: An interest in materials and a belief that materiality and sensuality have both tactile and associative characteristics

:: Ways of creating identity through ideas about home, personal testimony, mythology, and language

:: Investigations into the physical, psychological, and geographic dislocations that occur from stereotyping, politics, and colonialism

:: Challenging accepted norms and breaking down clichés of what is appropriately beautiful, violent, feminine, or ethnic

:: Broaching the gap between the public and the private, urban and rural, man-made and natural, real and fictitious while intervening in both

:: Uncovering the role of systems, theory, the media, and globalization in determining our place and beliefs

:: Use of irony, humor, and satire in commenting on the body and our relationship with our surroundings

Concentrating on these issues constitutes a shared point of view that underlies the organization of this exhibition, but we have not tried to define a movement or a generation. Whether it is the street culture of *Beautiful Losers: Contemporary Art and Street Culture* (2004) or the role of imagery in *Iconoclash: Beyond the Image Wars in Science, Religion and Art* (2002), many shows differentiate by inclusion or exclusion. At the other end of the spectrum are Dorothy Miller's ground-breaking shows of 12 or 14 Americans at The Museum of Modern Art (introducing 90 artists between 1942 and 1963) that concentrated, instead, on emerging or new artists. *Figures of Thinking: Convergences in Contemporary Cultures* falls somewhere between these points of view.

While not immediately obvious, all of the artists are women, but unlike exhibitions of the past decades from *Making Their Mark: Women Artists Moving into the Mainstream, 1970–1985* (1989) to *Inside the Visible* (1996) to *Sexual Politics* (1996), feminism isn't foregrounded in this show. Issues of gender, race, and religion inform the work of these artists but do not define it. We have assembled a group of artists we deeply respect to initiate a conversation about our world. This dialogue will hopefully offer alternatives and possibilities that confront any inclination to easily define and limit understanding for viewers and readers, whose own experiences and insights will carry the conversation forward, expanding the original impulse of this exhibition.

VAC/SP Spring 2005

Ours is an era that distrusts language, that fears figures of speech, and especially what could be called figures of thinking—ideas and associations that beget ideas, that link to other links in culture rather than in hypertext, ideas that are regarded as dangerous because they are not end-stopped.

Marjorie Garber

Process, the energy in being, the refusal of finality, which is not the same thing as the refusal of completeness, sets art, all art, apart from the end-stop world that is always calling "Time Please."

Jeanette Winterson

Collecting Our Thoughts
a conversation between
Vicky A. Clark and
Sandhini Poddar

As we age, we lose some of the wonder of young children busily exploring and expanding their worlds. We might still ask the question why, but sometimes we know too much to allow fresh answers to infiltrate our minds or capture our imaginations. Answers seem complicated, contradictory, rigid, confusing, and/or unacceptable. Even if we attempt to keep up with the rapid rate of change, we frequently try to fit new information into old and comfortable paradigms. Nevertheless, we must constantly process new information, even if we often feel out of touch or overwhelmed.

A couple of decades ago, before the Internet's power was fully realized, 41 million photographs were taken each day in America alone. Imagine what the number is now. How do we make sense of all that information? What is relevant? What is useful? What seems to be the truth? What works? What reinforces? What undermines? What is false? What is to be ignored? Can something be relevant to the group but not the individual? How do we determine our personal response, especially in reference to the community, nation, and/or world in which we live? How do we find our place in an ever-changing environment?

Conventional wisdom holds that things make sense when everything has a place and everything is in its place. This sought after order underlies most human endeavors from religion to science. Recently, however, we have begun to repudiate the need for strict ordering and recognize that process and change are the norm. This permits more nuances, confusion, contradiction, and that flickering presence just out of focus. It allows for Garber's "figures of thinking" and Winterson's "energy in being" and gives us the frame for our conversation and exhibition.

Vicky A. Clark: Figures of thinking: I love this idea because it encourages a consideration of many points of view and refuses the harshness of current political and religious rhetoric. It lets us continue to explore possible answers, to let our minds run wild. And it makes the work in our show fascinating because not only are there a plethora of answers, there are also so many different questions, even if, as we are trying to show, there is a commonality in the overall discussion.

Sandhini Poddar: I agree with you about figures of thinking. We have tried to keep our exhibition open-ended to invite interpretation in order to provoke viewers to look, think, and find the points of contact. The essay takes you through some of these convergences, referencing both larger ideas as well as specific works. This framework or approach is important to me personally. Having grown up as a Hindu in India, I really believe in a sense of continuity rather than a linear view of life; it goes back to Winterson's energy in being and the idea of not being end-stopped. I think that my predilection stems from the fact that India has historically been a country where democracy has survived because of the simultaneous coexistence of people from different backgrounds, social strata, economic access, community traditions, and even art forms. For instance, take any method of performance—the itinerant storyteller in the villages, the actor playing a part from one of the epics, or even the tradition of classical dance that emerged in the temples—and you'll find a palimpsest of interpretation. This inclusion, rather than exclusion, of various layers, from visual to performance-based traditions and from the narrative to the conceptual, provides a pulsating experience for the viewer. There is a simile that Buddhism uses to illustrate the coherence of form; it refers to Indra's

net, a wonderful fabric of threads and jewels hanging all over Indra's palace. Each jewel reflects every other jewel in such a way that simultaneously the net, in its entirety, is reflected in each of the jewels and each of the jewels, in its turn, is reflected in the whole of the net.

VAC: What a beautiful image. That simultaneous coexistence has always been true; unfortunately, power has a way of privileging certain worldviews and details while ignoring or even prohibiting others. Several alternate histories have been put forth in recent scholarship. Ideas of connection and multiplicity seem even more important today than in recent decades, especially in the US where politics have turned toward the right, and self-righteousness rules. We now have an environment, especially after 9/11, where any opposition or nuanced perspective is unpatriotic, and a con-servative, Christian mentality has infiltrated all aspects of life. The basic rights of democracy are being trampled at home while we attempt to free people around the world and give them those same rights. It seems ironic.

SP: You mention an interesting dichotomy between the cul-ture at home and the culture overseas. India is the world's largest democracy, but fundamentalist factions have sur-faced in the last decade, and the ongoing polarization between Muslims and non-Muslims all over the world will only increase tensions. There is an obvious danger in this process of ethnic and religious polarization, which makes a revisiting of work by contemporary artists of Muslim origin even more vital today. The exhibition *Beyond East and West: Seven Transnational Artists* that originated at the Krannert Art Museum last year is one such example.

America isn't only trying to democratize the world politically; it is also doing it culturally. Walk around any metropolis in India today. and you'll find a McDonald's on every corner. Even homes in shantytowns have 24-hour television access. Since 1992, when the Congress Party (center-left) came into power, India's liberalization policies and economic reforms, reinforced by the World Bank, have led to an influx of US businesses in the country. Several software companies and the controversial outsourcing industry have been born because of compromised protectionist attitudes, low labor costs, and the growth of a sizeable domestic market, coupled with India's proficiency in Information Technology and English. Inroads to globalization, however, haven't brought in the necessary education about population control or the hazards of sexually transmitted diseases, with many Indians still living below the poverty line.

VAC: The complexity of any situation is diluted in our media-saturated world where simplification, stereotyping, and misinformation make it hard to figure out what is happening. Despite attempts to understand other people and ideas, we haven't made much progress as most equate appearances with truth. I know that the networks syndicate the *Jerry Springer Show* around the world, and in return Japan sends us their samurai films and India gives us Bollywood. That's scary; no wonder we have no clue about other people.

SP: Yes, that's true. Few people realize that Bollywood actually commands and generates more money than even Hollywood. As a cultural phenomenon known to many people in the world owing to the Indian diaspora, it is now becoming part of our common consciousness as an expression of popular culture. On the flip side, the arts and arts education in

India are traditions that are not part of this consciousness, so it's odd to be living and working as an immigrant in New York City, seen by some as the epicenter of the art world today. There are few Indians in this field and even fewer who engage in contemporary art. This makes the attempt at creating a vision or sharing an opinion more vital in my mind. The finesse lies in being able to do this without privileging India over other cultures.

VAC: ...or ghettoizing Indian artists. It should be a situation of adding another voice to the mix, of introducing the contemporary art of India within the context of international art to a larger audience.

SP: In this respect, Rina Banerjee's art that addresses issues surrounding cultural influences and critiques is an apt example. Like the nine contemporary artists in the exhibition *Aliens in America, Others in the USA* at Phillips Exeter Academy in 2003, Rina's work has been intimately affected by her immigrant status. Having grown up in a traditional, intellectual family in Calcutta and moved to Queens at the age of seven with her parents, Rina frequently finds herself questioning what it means to be an Indian with a hyphenated identity. This self-reflection also relates to an inquiry into what India signifies for most people, from the land of self-discovery, yoga, and Ayurveda to the cremation grounds; from snake charmers and poverty-stricken beggars to Miss World beauties; from ruined temples, elephant carriages, fine jewels, and textiles to cows on the roads; from the Taj Mahal to Everest, Bollywood, and beyond.

Her video piece, *When scenes travel...bubble, bubble*, uses the format of a split screen to serve as a mirror between two worlds, between Rina as the American and Rina as the Indian,

between democracy transported and democracy elsewhere, between the urban and the rural, between development and subsistence, between the pop and the traditional. Filmed in Kerala in Southern India, the video knits footage of slow, meandering rivers in the so-called backwaters, with carrier trucks painted with iridescent flowers and "Horn OK Please" signs on the deathly highways and pedestrian traffic in crowded urban centers. In the spine of the doubled images, text recedes, mimicking fading memories. Phrases like "twin world" and "potions made of heritage" are accompanied by garish Bollywood music. These usages of identity as well as miniature-sized stills that appear as delectable jewels seen under magnifying glasses all speak to the notion of the souvenir.

VAC: The souvenir is always a memory device, a way to access past experiences, and Rina's superimposed words activate memories that affect the narrative. As the text references the declining oral tradition of an old order, it also accesses current ideas about merging fact and fiction. The video and the girl's future both exist between several worlds. There is a loose narrative of a trip in the mirrored images, which slide between scenes of popular culture and street life. Rina creates a kind of floating world that isn't anchored in the past or the present but which speaks across cultures.

SP: I think that this ability to speak across cultures is intrinsic to our exhibition. For some time now, I have had issues with artists living in India who use the platform of being Indian contemporary artists as their sole means of identification. This dependency on a recipe for identity or ethnicity reflects a certain myopia and isolation and relates back to the lack of arts education in India, as production takes place

without a sense of context for what has come before and what is happening in the contemporary field internationally.

VAC: That myopic view is part of the reason that identity politics have become problematic. As Westerners became enchanted once again by other voices and visions, we raced to look at art and artists from around the world. A genuine interest turned into a marketing strategy very quickly despite questions of co-option and political correctness. Reacting to past omissions were several shows, the most significant being *magiciens de la terre* in Paris in 1989. Its curators attempted a more UNESCO approach but it was still difficult to view a Western work of art and an African ritual object simultaneously, something that was even more problematic in the 1984 primitivism show at MoMA. It is hard to compare such different objects without value judgments getting in the way.

SP: The exhibition in Paris was both controversial and groundbreaking and continues to serve as a benchmark for current discussions. It seems to me that the only way to play a transformative part in the larger world arena is to drop any limiting associations and try and position oneself as a contemporary artist first. This is not a direct rejection of one's identity or ethnicity, as it is important to draw strength from one's heritage, but rather a way to transcend limiting clichés and make arguments that cross over multiple thresholds.

VAC: That's the starting point of this show. Identity, gender, and politics have become integral to our way of thinking, but they are no longer front and center. They are part of our belief system and a filter through which we see the world. A. S. Byatt expressed this idea so well in her novel *Possession* when she called her protagonists "theoretically knowing."

They knew so much about the theory of love that they had no clue how to be in love. As we move beyond postmodernism, we take its lessons with us. I believe that we need to move from seeing difference to finding similarity. This shift was set out convincingly in Terry Eagleton's *After Theory*.

You and I kept finding a commonality among the work we liked, despite the incredible differences in experience and background of the artists. Of course you and I come from very different backgrounds and eras; you are from Hindu India, and I grew up in 50s America and became a child of the 60s. But we share a sensibility. I have come to distrust the idea of universals, but I do believe in commonalities; the difference, more than just semantics, allows individuality within the reality of being human.

SP: This belief in commonalities, in convergences, in cycles, and in synapses reminds me of Jorge Luis Borges. In *Labyrinths*, he talks about how immortality is difficult to understand. He finds it both divine and terrible as Jews, Christians, and Muslims see it as a reward or punishment for this mortal life. There is no connection to what we experience because death is an end beyond which there is nothing we know. The image he contemplates is the wheel found in certain Indic religions. The wheel, of course, is a circle with no end or beginning, suggesting that life is also continuous.

VAC: While the circle is an age-old symbol, I prefer to think of the moebius strip, a never-ending loop with the potential for turns and changes. I personally don't think in terms of religious symbols; instead I like the idea of mapping. In the early stages of our discussions, we both talked about the work of Mark Lombardi as an example of mapping connections.

Just like Lombardi's pencil marks proliferated into intense networks of contacts and connections, an aesthetic parallel to the popular exercise of six degrees of separation, our conversations elicited an increasingly dense web of connections between the works. As we reworked our conceptual map, we found commonalities, characterized mainly by a refusal to allow ideas to be codified or end-stopped. We attempted to avoid the categorization that leads to dangerous misunderstandings and limitations. This open-endedness can lead to charges of soft thinking, but I am comfortable with that.

SP: We share a sensibility that stems from a sense of mutual respect for each other's cultural attitudes and what our individual histories and experiences bring to the discussion. It is a formula of reciprocal offerings as ideas bounce off and feed each other. This reciprocity seems endangered these days. I recently learned that the US is starting to impose very strict border controls in a manner similar to the European Union's struggle against immigrants. At a time when the US is feeling threatened, I am concerned about whether the country will want to sustain its once legendary status as the land of opportunity.

VAC: Even with new restrictions, the US is still a melting pot. Just look at last year's exhibition *Working in Brooklyn*, which featured many nomadic artists who, like you, grew up in one country and moved to another. Travel and moving disrupt our normal patterns, taking us outside of and away from our usual habitat. This experience of dislocation creates a hybrid nature, something that has always existed but has become defined with more travel and new technologies that allow for an increasingly rapid exchange of ideas. James

Clifford talks about travel, in all senses of the word, in his book about roots and routes.

Zarina, for instance, lives in a studio apartment in Manhattan. That is currently her physical dwelling, but her home also incorporates things, and more importantly, feelings and memories from other domiciles. She carries these with her to each new location, imbuing it with a sense of identity, belonging, and history. Sometimes travel leads to odd disconnects. I bought a t-shirt at Cabbages and Condoms, a Bangkok restaurant and gift shop run by a non-profit family-planning group. My tee features the Mona Lisa with a condom in her hand. How did the Mona Lisa travel from Renaissance Italy to modern-day Thailand to promote birth control? Why didn't the Venus of Urbino and/or Olympia go instead? This type of travel/transmission fascinates me because it is hard to chart. Many of the artists in our show have made major moves while the others travel a lot, so all are subject to a variety of influences. These physical moves are matched by mental shifts that affect the work as well. One of the easiest ways to deal with change is to rely on the familiar, a process that translates into the commonality we have seen.

SP: The beauty of Zarina's "Home is a Foreign Place" lies in its evocation of visceral sensations. The series of 36 woodcuts tells the tale of an itinerant wanderer who embarks on a journey from her father's home in India to experience the waxing and waning of the moon, the stillness of the night, the dew the next morning, and the despair and travails of leaving all that is innocent and familiar, only to come back full circle to the same resting place but in another locale. Zarina's journey is not just physical but of the mind and

speaks to the isolation felt by many immigrants who are transplanted to new cultures, looking for and trying to reestablish their sense of home. She grew up as a Muslim woman in Aligarh, a small, dusty town 40 minutes away from Agra with its inimitable Taj Mahal, and has been living in New York City since 1975. In *Directions to My House*, Zarina describes the way to find her red brick family bungalow in Aligarh through local landmarks, neighboring crossroads and alleyways, and latticed bougainvillea with intimacy and detail, only to have us realize that we must travel 7,438 miles from the US to reach her ancestral home. She evokes the sights, sounds, and smells of home, all the while knowing the dissonance that comes from great distance.

VAC: It is in such details that we begin to understand dislocation. Statistics can be revealing, but they are cold. Suggesting the visceral, especially in the visual, adds a meaningful layer and is another commonality in our show. Lesley Dill, for example, lived in India for a while, no doubt experiencing the smells and sounds referred to by Zarina. As a foreigner who did not understand the language, she was able to hear patterns of sound. I can imagine her reaction as I listen to you; even when you speak English, there is a beautiful lilt to your voice. I sometimes find myself enjoying your rhythm so much that I miss the words themselves.

SP: That reminds me of something Roland Barthes wrote about in *Empire of Signs*, which I find very beautiful: "The murmuring mass of an unknown language constitutes a delicious protection, envelops the foreigner...in an auditory film which halts at his ears all the alienations of the mother tongue: the regional and social origins of whoever is speaking, his degree of culture, of intelligence, of taste, the image

by which he constitutes himself as a person and which he asks you to recognize. Hence, in foreign countries, what a respite! The unknown language, of which I nonetheless grasp the respiration, the emotive aeration, in a word the pure significance, forms around me, as I move, a faint vertigo, sweeping me into its artificial emptiness, which is consummated only for me: I live in the interstice..."

VAC: Barthes describes a liberating experience. Those interstices, pauses, and in-between spaces are powerful and freeing. Lesley made sense out of the foreign language by recognizing patterns, one of the earliest methods of ordering. We can see that interest in patterning, both ordered and spontaneous, in her curtains of thread or horsehair. Creating dancing shadows on the wall as they move in the breeze, these curtains function as veils that simultaneously hide and reveal meaning. Her materials are simple and evoke a myriad of associations from women's work to beauty to bodily functions to ethnicity to Rapunzel and Lady Godiva to hairballs and hair in the shower drain. Words shaped in copper and wrapped in organza are poetic, emphasizing once again associative characteristics. Lesley seems to play off of contradictions and doubles in her work, implying that they actually cohabit rather than fight. Leaving much to the viewer, she likes to come to her ideas and work from an oblique angle, echoing the words of poet Emily Dickinson who encourages coming at things from "a slant." Lesley uses words like Dickinson, associating her work with poetry and music, leaving behind the linear and the concreteness of the everyday.

SP: Her fascination with Dickinson also has to do with a need for spiritual transcendentalism. In *Blonde Push*, she uses one such text—"Force Flame/And with a Blonde push/Over your

impotence/Flits Steam"—in a work made of wire, horsehair, thread, and tea stains. The use of materials, of signs, and of symbols evokes the unutterable, the untranslatable, and leads to the manifestation of what is essentially unmanifest.

Lesley's language serves as a means to understand the self and create a personal testimony. It seems to me that her use of a secret language to delve into the subconscious parallels an ancient Tantric practice in India. Just as believers needed initiation into that philosophical system in order to read or decode the hidden mystical truths embedded in a temple's sculpted recesses, we, as viewers, require similar initiation into the artist's inner workings in order to fully understand her choice of poems and their associative qualities. In *Language Extends Even to the Hair*, a large-scale wall installation with wire, thread, and organza, Lesley uses a phrase from Pablo Neruda: "Human word syllable Blended Existence with Electricity Communications of the blood Language Extends Even to the Hair...." The corporeal qualities of language, the relationship between text and identity, and the use of the body as an intrinsic means of self-expression are poetically strung together in copper wire. Lesley's system of belief seems to follow what Barthes writes about in *Empire of Signs*, where he sees Japan as a place where people rely on the body, rather than purely on words, as a means of communication. He talks about the ritual involved in making a date through gestures, drawings on paper, and proper names that may take up to an hour. During that hour, we get to savor and receive the other person's body, which slowly displays its own narrative, its own text.

VAC: Barthes' example encourages a slowing down, which has little place in our current environment. Bits and bytes,

multi-tasking, and information overload have made us impatient. Our artists are like Barthes, luxuriating in slowness and quiet. Perhaps if we take the time, we can begin to understand the intangible, ephemeral, and unknowable.

These installations are unusual in Lesley's body of work in that she is usually more direct, using body parts and clothing as loaded surfaces for her marks and words, just as Cheryl Yun uses lingerie and purses as the canvas for her satirical, political, and cultural concerns. While Lesley does use the body, Cheryl leaves it behind, using clothing as a surrogate.

SP: Both are interested in patterning. In *Abstract One-Piece*, Cheryl incorporates shrapnel that simulates loose running stitches across the surface of the work, like a body cross-hatched with sewn up wounds. As she says, "I am seduced by the patterning and the way something beautiful is created out of something horrific."* Danger lurks just below the patterned surfaces of her lingerie. Photographic negatives slowly reveal themselves as body bags, caskets, bomb jackets, portraits of political prisoners, and world leaders. Cheryl means to provoke and unsettle us, but she garbs her loaded political messages in a humorous cloak. The playful bathing suits and negligées invite our curiosity and inherent voyeurism. Rather than getting a sneak peak at the female body, however, we are given a rude awakening. Ironically, several themes that have to do with war and control, domains mostly created by men, are sculpted into feminine forms. Camouflaged American soldiers in *Tac* hold former Iraqi soldiers at gunpoint and are difficult to distinguish from their protestors. Body caskets of Bosnian Muslims massacred in Srebrencia, in the work *Baby Doll*, become a grid of lines, couching any reference to violence or injustice in geometric artistry.

As spectators to these crimes, we are kept at a distance, similar to how the media manipulates and skews the realities of war. At any given time, we only know partial truths and are not privy to the actual goings-on of political puppeteers. Cheryl's use of the repeated pattern of bomb jackets in her line of lingerie is a potent comment on another false and dangerous fantasy of self-empowerment used as a strategic political device today. Seen as early as 1991 in India, female suicide bombers have consistently been used as a terrorist tactic. In the Middle East, within an Islamic context, they and other devout but extremist Muslims blow themselves up in the name of religion, in the hope of attaining paradise. The Japanese tissue on which these images are printed is also fragile and non-archival and reminds us about corporeality and mortality.

VAC: Cheryl chooses the most intimate clothes, implying that distance from current incidents of violence is manufactured and can be shattered in a moment. Making sexy garments with beautiful folds, she personalizes the violence that is usually reported in statistics. Her work also plays with the ideas of the inside and the outside. We all present a face to the world that is sometimes at odds with what we feel inside, yet we tend to take so many things at face value. More than mere body coverings, Cheryl's clothes warn us of the dangers of mistaking appearances for reality. There is also this sense that the truth lies somewhere in-between, hovering between the intuitive, inner world and the visible, outer world with borders and interstices becoming sites of negotiation.

SP: Wangechi Mutu is another artist whose work literally and metaphorically hovers between two worlds. Although

she hasn't returned to her native Kenya in nine years, the process of bringing her roots in traditional African myth and storytelling to bear on larger issues of social and political injustice, by means of a contemporary aesthetic, gives her a rich voice. Wangechi oftentimes references the social and environmental exploitation of Africa's labor and natural resources by ironically transplanting cut-out collages of Harry Winstonesque diamonds on the bodies of women in the West. She thus questions "society's use of the body of the woman as a site on which its catastrophes and quandaries are played out."

VAC: The Hottentot Venus, a 19th-century tribal woman who was exhibited nude at the world's fairs in London and Paris, was and still is an example of ideology played out on a woman's body. She was the most visible symbol of that century's pseudo-scientific research, which was partially fueled by colonialism. Anthropological, medical, and literary sources combined to create in her a potent symbol of the dangers of the sexualized woman, an ideology played out in Olympia's servant Laura. Like images of the Hottentot Venus, Wangechi's collages of women play with the issue of the exotic, which so easily slips into the erotic.

SP: The Hottentot Venus had a name: Sarah Bartmann. Apart from this public scrutiny, she was apparently also subjected to an infamous dissection after her death at the age of 25.

VAC: And her bones were in the collection of the Musée de l'Homme in Paris.

SP: Her story of exotification and ensuing falsehood reminds me of another instance to do with history. The Taj Mahal and other Mughal building complexes, as you may know, have

generated many romantic myths, most of which are spurious in nature. For example, the Mughal emperor Shah Jahan had supposedly planned a replica of the Taj across the Yamuna River to be built in black marble. However, the plan could not take off as his son Aurangzeb usurped the throne. This myth became popular, mainly due to the French traveler Tavernier. However, according to archaeologists working on the site in India today, there is no historical record of such plans. Only ruins of some gardens remain on the opposite bank. Has the presence of these gardens led to this myth? Possibly.

VAC: These myths have a way of insinuating themselves into history, coloring our understanding of the past. It makes sense to have a double of the Taj in black, so we accept that story. Like memory, history is subject to capricious change. Certain places, like the Taj, become mysterious icons; in the West, it is a monument to the exotic East, with desire and longing associated with fantasy. Surely there are other examples. What about the symbolism of the Twin Towers in New York City or Hagia Sophia, the Roman colosseum, Chartres, or even the lost continent of Atlantis?

SP: In *Take Me, Take Me, Take Me to the Palace of Love*, Rina presents a lavish hot pink saran wrap model of the Taj that has to do with all the exotic qualities of Orientalism. As these continue to thrive, her interest in post-colonial studies probes and tests the international perception of the other. Rina's vision is also not without satirical humor or comment. Rather than simulate the Pietra Dura wall finish of the actual monument, she uses a kitsch chemical commodity as a substitute to erect her own ode to history. The clumsiness of the material, she says, is an important quality of the work as it

provokes viewers into a state of ambiguity, necessary in confronting any preconceptions. Rina also uses a playful Bollywood movie song as the title for the piece, further subverting its historic foundations. These contaminations parallel the skewed perspective a colonizer might have of a culture once it has been conquered. Hovering over a globe in the center of the Taj is a finely carved post-colonial chair, reminiscent of a Mughal emperor's throne, which would have once symbolized omnipotence and sovereignty over his people. Rina includes other realistic allusions to anchor the work. The pink monument floats above the gallery floor and casts a reflection in a manner that simulates the actual site in Agra. At a time when we still categorize certain cultures outside of the US-Western European axis through myopic rose-tinted glasses, the installation offers a variety of ways of distorting our clichés and limited viewpoints.

VAC: These limited views of other cultures have a long and checkered history. Going back to the Hottentot Venus, we have a horrific example of an ideologically loaded viewpoint. The European fascination with the other was fueled by the discovery of new lands and the enlightenment, which inspired a growth in knowledge. It also, however, spawned misconceptions, many of which survive today. Difference was studied and analyzed, and the case of the Hottentot Venus is just the most visible example of that tainted research. Amazingly, similar studies were included in medical publications after World War II with doctors studying lesbians instead of Africans, something I learned from the work of California artist Millie Wilson.

Simone Leigh uses the compromised Hottentot Venus to reflect how ideas travel. As an African-American, she is

constantly faced with questions about her African origins even though she has never been there. Her knowledge of the African peoples comes from the same sources as most non-Africans. In an ironic twist, she returns the Hottentot Venus to Africa by covering African water vessels with stereotyped voluptuous breasts. The obvious metaphor of the woman's body as vessel comes into play, but the round forms could also refer to the large buttocks that so fascinated Europeans. Simone plans to fashion an oversized ornamental brooch out of several vessels in a future piece, perhaps a subtle reference to the necklace that the naked Bartmann wears in several historical prints.

SP: The overall structure of the proposed brooch also relates to Rina's jewel-like video stills; both artists comment on cultures that can seem quaint and desirable. Simone's use of the rounded forms and pendulant breasts to overlay the clay also takes me back to ancient terracotta figurines of the mother goddess, worshipped before the ascent of the male gods. As symbols of the earth's power, the feminine deities were evoked to protect communities from natural calamities, and women having difficulties bearing children tried to placate them.

VAC: It's interesting to realize that almost every mythology or belief system has these figures to answer basic needs of the community. The mutability of these figures is amazing as each era and culture molds them to fit their own needs.

SP: This mutability happens to individuals as well; Simone's background is layered with Asian, African, Caribbean, and American roots. I was surprised to learn that Simone's father changed their family name from Lee to Leigh when they moved to the US to avoid any references to their Asian roots

in the Caribbean. This morphing of identity concerns her on many levels. She says that "the history of colonialism parallels the history of ceramics. What started out as a medium associated with the East (China and Japan especially) is now considered as a product of the West." Simone comments on this appropriation of ceramics through her use of several kinds of glazes and surface treatments, which reference trade routes or journeys across the East to the West. In using natural whites, beiges, dirty grays, crackling creams, pale pinks, chocolate browns, charcoals, and dull blacks as her color palette for the most part, she casts her ceramic breasts, vessels, plantains, and chandeliers in a certain anthropological light as a subtle commentary on sexuality, race, and ethnicity. The breasts take on different associations, from torpedoes to acorns to teeth to pouches to sacks, and are alternately aggressive and nurturing, humorous and transgressive.

VAC: At first glance, you don't necessarily recognize her forms as breasts. Once I did, I felt a tension created by the use of fragmented body parts, traditionally associated with objectification and sexuality, as building blocks of another form.

SP: Wangechi also uses fragmentation in her work as she appropriates and combines images from *National Geographic*, traditional African art books, fashion, car, and biker magazines, and the mass media for her collages. In so doing, she straddles art and science, the man-made and the mechanical, fact and fiction as she references ethnographic photography, forensic mug shots, wildlife illustration, and glamour shots. Like Cheryl, whose images are chosen to "represent the ambiguity of representation in our current political climate,"* she too is concerned with trying to uncover the role of the media in determining our place and beliefs.

Several of Wangechi's women, with motorbike parts and engines for hands or legs, are simultaneously beautiful and vicious and portray aspects of African identity and femininity. Accompanied in several instances by half human/half animal tricksters that jump, balance, or ride off the women's bodies, these portraits explore stages of transformation and mutation, like the processes of memory or myth that change and shift reality. The intricate surface treatment of washes and pours, with different inks for the mottled skins of the female protagonists, along with the use of sequins, tinsel, beads, brown duct tape, human hair, and fur, combines aesthetics with appropriation. Like other artists in this exhibition, the materials used have associative characteristics that bring to mind the work of artists like Eva Hesse.

VAC: And Joseph Beuys. Wangechi uses an implied narrative in her work. I look at her fantastic (as in not real) creatures and think immediately of mythological, magical figures, mainly hybrids that do not exist in nature. They wield power from another world. By adding these creatures to the purloined images of models, Wangechi takes the figures beyond the usual association with stereotypes, enriching them with allusions to fairy tales, mythology, and science fiction. They also remind me of spirit photography where the spirits of the dead appear in the company of the living, hovering over them as they protect or haunt them.

SP: Mami Wata is also an image from another world, a deity that both protects and haunts us. In her installation named after the goddess, Simone knits ceramic breasts together with wires to form a boat or cradle, a symbol of slave ships. When seen from a bird's eye view, all the ceramic pieces are huddled closely together and remind us of the kind of

inhuman circumstances that the slaves would have undergone in the bowels of the boats. She adds that this view "is in the visual consciousness of most African-Americans. I also see boats as symbols for the diasporic movement of culture, and the flux and shift involved in Mami Wata's 'nature' in its highly ambiguous bi-sexuality." Although Mami Wata's outward form is that of a beautiful woman with fair skin and black flowing hair, her role is not gender specific. The ceramic pieces are colored red and white, a reference to the dichotomous nature of a deity that is fearsome and spiritual, malevolent and benevolent, masculine and feminine. In her ability to capsize boats or strip away fertile grounds, Mami Wata also may be seen as a symbol of colonialism, as Africans have slowly but surely come under the influences of Western, Islamic, and Indian cultures and beliefs.

As a deity whose image has an Asian derivation but who has also been used in German lithographs, venerated by the Igbo tribe in Nigeria, and known as St. Catherine in the Caribbean, Mami Wata is certainly of pan-human lineage. I think that the narrative involved in her travel across cultures would make an interesting bed-time story for children in many parts of the world.

VAC: Once again we see the mutability of a mythological character, reflecting a basic need to make sense of the world through anthropomorphizing important characteristics. Each culture adds or subtracts to the story and/or personality as necessary. I would interpret Mami Wata not in terms of dichotomies but as a chameleon with a multiple personality whose nature changes depending on which aspect is in ascendancy.

SP: The idea of the chameleon brings me intuitively to Ellen Gallagher, whose paintings, drawings, and films embody

those very shifts and changes and may be considered as figures of thinking. Her style defies easy description as she invents, reinvents, subverts, and intervenes in representation itself to comment on notions of identity and transformation. In works that are both playful and ponderous, she challenges our assumptions about ethnicity and race in both historical and socio-cultural contexts. Her distortion of form, brimming with wry humor, is reminiscent of Toulouse-Lautrec in her use of caricature to comment on stereotypes and personal idiosyncrasies. The group of prints that she made at Columbia University in 2000 is very subtle and minimalist in its overall aesthetic, and yet the groupings of abstracted and bulging lips, mouths, and eyes appear almost baroque in certain scenarios. In one example, they morph into an underwater sea creature, a harbinger to the later "Watery Ecstatic" series of 2004, while in another they appear as if in a large crowd. In their ability to take up different meanings depending on their situations, Ellen comments on the morphing of identity constructs.

VAC: It fascinates me to see the use of the large lips in these prints for they recall the faces of problematic images of the white-faced black minstrels and pickaninnies in American culture. Ellen mines this contested territory in several works; elsewhere she concentrates on hair as a point of difference accentuated in discussions of race and ethnicity. By owning these familiar clichés, Ellen makes them into a mark of identification with a larger group, a sign of belonging.

SP: Ellen exploits variegated techniques of printmaking and draughtsmanship and utilizes a highly personal vocabulary or lexicon of symbols and pictographs. The prints remind me of miniature paintings in their ability to be cohesive from

afar and simultaneous requirement that viewers come up very close to the surface to decipher their action. The reiteration of forms, one slightly different to the other, is also similar to miniature paintings in their ability to show the transition of time as a continuous narrative appears. Her method of slowly building up the surface of her subjects through endless repetition is fastidious and almost meditative, and connects her work to Heesung Yang's.

The absurdity and cartoon-like imagery of some of the Columbia prints forces us to reckon with our own judgments about categorization, compartmentalization, and representation. The fragmentation of form is similar in strategy to the work of other artists in this exhibition. In one print from the group, Ellen presents a black oval, almost suggesting that we take a good look at our own quirks and disconnections in the mirror. Peering out back at us from the ebony darkness, the eyes and lips are also confrontational and force us to reassess our roles as viewers and voyeurs. The chameleon-like nature of the print series finally manifests itself through the combination of ornamentation with obliteration, beauty with irony, free form with meticulous craft, symbolism with abstraction. Through these multiple sets of dialogues, Ellen excites our imagination and leads us to new ways of thinking about and viewing our perceptions of the other.

VAC: Ellen also makes use of implied narrative in these works in a manner that links her work to surrealism. As you said, within the series there is a conversation going on between the small incidents within each work. The connections are intuitive and unexpected as most surrealist juxtapositions were. Viewers have the luxury of writing their own stories.

Narrative has returned to prominence in the last few decades. As we have struggled with how to understand the other, we have come to storytelling as a way to include the authentic voice of the other and to share histories. Telling stories is, of course, an impulse in all cultures and all eras. It is harder to do in visual art because a narrative needs time to develop while most artwork is static, taking video and film out of the discussion for the moment. Recently many artists have turned to comics and graphic novels to find a way to insinuate a narrative; Ellen's imagery is connected to comic and cartoon images in a loose way. A couple of years ago, Barbara Weissberger covered walls with enigmatic grotesques reminiscent of Goya's creatures, deformed figures from comics and cartoons, or mutants from science fiction as a way to comment on current political, social, and cultural conditions. She develops her story across a wall or a piece of paper, arranging tableaux and figures in a seemingly spontaneous way. The viewer reads the work by putting together all the pieces. It is almost as if she took a Bosch painting and exploded it, leaving fragments on the wall.

SP: Like Barbara's work that requires viewers to connect the dots in order to get the bigger picture, Nina Katchadourian's "Mended Spiderwebs" series combines video with photographs and actual mends to map the subject. Nina questions our natural inclination as humans to intervene in nature when working with spiderwebs that she found at her family's summer home on an island off the coast of Finland. Like an over-zealous guest, she takes it upon herself to tidy up nature by repairing incomplete or damaged spiderwebs in her backyard. Using scissors, pliers, and gaudy red threads to stitch and glue the webs back together, she focuses our attention on this blatantly unwelcome and violent act. In her

video piece, *GIFT/GIFT*, we see her struggling to attach the letters G-I-F-T on to a spiderweb and the battle of wills that follows as the spider literally casts off each letter one by one. The works in the series reveal hidden assumptions we make about human dominance and comment satirically on our skewed relationship with objects and systems in our world.

VAC: I have a kinder, gentler reaction to her dialogue with the spiders. I find these pieces very funny; in *Marketing Tips for Spiders*, she inserts an ad for her services on to one web, as if the spiders, who consistently rejected her mends, could read. I also think that she is trying to restore order to help the spider; the irony is, of course, that the spider doesn't want her help. Nina touches on so many themes we have been discussing. The spiderweb itself is an ordering system based on an intuitive pattern, but it hints at danger because the spider uses it to trap his food. It is also his home; a place to call home continues to be a potent image when thinking about identity and place. The web is woven, an image associated with women's work. Of course I don't know if the spiders who weave the web are male or female, but in our culture, the assumption is that they are female. You only need to read Donna Haraway's article "Teddy Bear Patriarchy" to see how human roles are cast upon animals, as she corrects the mountain lion diorama at the natural history museum in New York City. There is a strand, forgive the pun, of feminism in Nina's work—in all the work in the show, in fact—as Nina makes a piece with various layers of meaning, accessing ideas from feminism without them being the focus. It is a lived rather than a confrontational feminism.

SP: Yes, the struggles are much more internalized rather than explicit or political within the framework of feminism's

previous agendas. Although you consider yourself a feminist, we are not foregrounding feminism in this exhibition but rather coming to it from "a slant." An exhibition with 14 female artists doesn't necessarily have to be about feminism. To assume that is to fall into another kind of trap or court a certain prejudice.

VAC: We didn't start out to organize a show of women artists; it was the work and the ideas that led our efforts.

SP: Yes…while we did consider the work of some male artists for this exhibition, the way that the connections and convergences developed dictated our final curatorial decisions. Like the personal philosophies that we embody as human beings and the way in which we approach each other and other cultures, the show grew organically as much was understood without ever having to be stated or over-stated. The artists in this show do have a shared sensibility, but this goes beyond their gender, ethnicity, and age. There are larger themes of the body, identity, fragility, patriotism, dislocation, transformation, and spirituality that are more meaningful to us.

VAC: The ideas deal with the reality of being human in a very complex world in a way that encourages us to think in different ways. The lessons of feminism and postmodernism have been learned, but that doesn't mean that they can now disappear. In fact, I was surprised to read recently that despite years of recognition of imbalances in the art world, many believe that we still need to include more voices. What has changed is the strategy. Feminism is still important and almost all women, and probably most men, have been influenced by it in some way, even if they do not acknowledge it. But it is only part of an artist's vocabulary, just as

technology has now become just another tool for them to utilize. It's now second nature, so it is part of the ideas of our exhibition even though it is not its raison d'être. It's like Teddy Roosevelt's foreign policy: speak softly and carry a big stick.

Mona Hatoum's work, for example, can be unassuming yet treacherous, like Dave Hickey's "dangerous beauty." I remember the first time I saw her hairballs on a wooden floor. Something mundane and often discarded suddenly animated a room, giving me the shivers. Women's body hair is something not to be seen, even in representational painting or, more recently, fashion photography because it mars the idealistic perception of the body. Perhaps it is too intimate as well.

Kathy Prendergast also relies on a kind of intimacy in her small work *The End and the Beginning II*, threading hair from three generations around a spool. This small surrogate packs a powerful punch, adding a more positive spin on hair as something inherited, something personal that continues through the generations and contains traces of ancestors, including DNA. By using a spool as the container for the shed hair, she references women's work. She transforms something abject into a figure of thinking that is beautiful, sensual, and provocative. Both Kathy and Mona make works that move easily from the mundane to the sublime in just seconds.

SP: Yes. Kathy's sophisticated understanding of how scale conveys messages and her play on dangerous beauty relates her to Mona. Added to this is her sensibility of using unusual materials ranging from broken eggshells to marble chippings to human hair, moth eggs, and mittens. As an artist who has been concerned with a cluster of universal issues surrounding

the body, identity, power, politics, mapping, and sexuality since the 80s, Kathy's work remains intimately involved with individual experiences. She thus has the capacity to encapsulate the symbolic in the most singular of forms. In *The End and the Beginning I*, birth, childhood, aging, and death are all captured in one small sculptural object, a child's white bonnet with strands of aging human hair. It brings to mind a line from an ancient Indian philosophical treatise that states, "I was born dying." Several of Kathy's works, like this example, have to do with the fragile, the ephemeral, and the simultaneous processes of growth and decay. Like evolution and involution, one exists because of the other. I wonder whether she would agree with what we were discussing earlier about Borges' wheel of life or if she would take an existential position.

Apart from these philosophical musings, there lies a strangeness and ambiguity in Kathy's work that reminds me of Rina's use of obscure materials and references in some of her installations that provoke us to think laterally. The equivocal arises because of the use of symbolism and coding; tenuous subjects such as loss and love are cloaked in suggestive garbs. In *Secret Kiss*, Kathy cleverly obscures two facing heads, which I see as lovers, in a continuous piece of knitted wool, which provides a certain privacy and eroticism but isolates the two lovers from the rest of the world, thereby forcing them to confront one another. Kathy's drawings, sculptures, and installations rely on occasions of human vulnerability or transition when we stand poised at life's crossroads. They have to do with those pivotal moments when life can go either way: when we are born, when we fall in love, when we sleep, when we move from place to place, when we age, and when we die. Like many

other artists, she too uses her art to try and understand the human circumstance better.

VAC: Often we don't even sense transitions or change. Psychotherapy helps us with that, usually after the fact. The relationship between seeing and not seeing or seeing things in a new light comes across in Kathy's *Secret Kiss.* I cannot see this work without thinking of terrorism because Rosemarie Trockel exhibited a series of knit balaclavas, the ski masks favored by terrorists. It would be wonderful to see these works together; the viewer would understand how any object can be seen in different ways, depending upon the details, context, and especially the times. The same is true of Mona's domestic objects such as the larger-than-life egg slicer that owes a debt to the humorous sculptures of Claes Oldenburg. By altering the scale, Mona heightens our perception of the everyday, making a horror movie object of domestic disturbance — an evocative title of a recent, one-person exhibition — that rates up there with the cooked bunny in *Fatal Attraction.*

SP: Mona's work is carefully crafted like a double-edged sword and is often macabre and humorous in its iconography. It has the ability to shock us out of any sense of false complacency we might have about the wellbeing of our body or the safety of our surroundings. Her hospital beds and crutches — symbols of stability and reassurance — are cast of rubber that bends, twists, and falls to the floor, limp and impotent. They remind me of Dali's clock faces that lose definition and start to flow like liquids. By transforming the familiar into the uncanny, Mona has been influenced by the surrealists. Objects from our quotidian lives like ladles and colanders, associated with home, domesticity, and

nourishment, grow thorns and spikes and force us to tread lightly on what seems like familiar ground. In installations with kitchen utensils charged with electric currents, there is a sense of urgency, of a hostile reaction to domesticity and the kinds of expectations that come from growing up in chauvinistic societies. Some of the utensils are then used towards another, more apparently aesthetic purpose. Her series of rubbings of cheese graters and colanders on wax paper appear as beautiful constellations or networks of nerve endings but leave a horrifying impression on us, as we are left to imagine how or why those marks were made.

VAC: Mona has used graters in a number of pieces, taking advantage of the ordinariness of a kitchen implement that can cause pain if one grates a finger instead of the cheese. They appear in all sizes and materials, becoming animated actors in her plays about domesticity, especially when appearing in shadow form in her waxed paper edition. The crinkled paper, similar to what we find in our own kitchen, looks like skin and evokes a ghostly apparition. Absence plays an important role in Mona's work with the human presence only suggested. Her objects from the mundane kitchen tools to hospital beds—which I see as the site of disorientation, anguish, and anxiety instead of your perceived safety—become icons and perhaps stand-ins for humans.

Mona approaches the body more directly in pieces like her entrails carpet or the video of the inside of her stomach. These are riffs on scientific investigation, revealing facts about the human body, facts that exist in a vacuum, just like our DNA, and need to be contextualized. If you put these body works by Mona together, you would come closer to understanding many more aspects of a human being. Her

beliefs are embedded within the objects she chooses. I think the same is true of Wangechi's video *Cutting*.

SP: Wangechi's investigations into the use of the body as a geo-political map surface in this video, which was filmed in the diminutive US-Mexico border town of Presidio, Texas. The area's aridity and isolation, especially the particular quality of the desert soil that turns blood red at sunset, set the scene for Wangechi who inserts herself in the role of "every woman." We see her alone atop a small desert mound, silhouetted against the setting sun, dressed in a traditional worker woman or housewife's garb, wielding a machete against a block of wood, an action that slowly but ultimately exhausts her. The repeated clanking of the metal causes our hair to stand on end in the silences between each breath. The woman in *Cutting* thus symbolically battles against her personal injustices and, consequently, the inhumanities of the world at large.

VAC: This repetitive action is mirrored in the actual process used by Heesung Yang as she works and reworks the surface of her paintings, producing post-minimal works with nuances of women's work, meditation, and transformation. Like Ellen, her works share a sense of the sublime with those of artists like Agnes Martin. Most of the artists in our show are part of the post-minimal sensibility where materials and meaning are inserted into the reductive forms.

SP: Working alone in her SoHo studio, Heesung spends countless hours diligently coating unprimed canvases with layers of thick acrylic, patiently waiting for each layer to dry. Having built up the surface paint to almost 1/8 of an inch in thickness, with over 15 layers of paint sandwiched in between, she then gouges out the paint with an eXacto

knife into thin strips, in a slow meditative process. It is almost a case of obsessive compulsiveness, as process borders on meditation that borders on madness. As the coagulated paint strips are tweaked and pulled, twisted and nailed, crocheted and bound, Heesung transforms the surface of an otherwise traditional canvas into a living, sculptural object of great formal beauty and technical brilliance. The play of cascading shadows and of recessing and projecting spaces lends three-dimensionality to an essentially two-dimensional structure and parallels Lesley's thread and horsehair installations.

Her sensibility for color also relates her to Rina and Simone in that each color has the ability to evoke a certain emotional response. It seems to me that the china whites in her works have to do with quietude, boundlessness, and loss whereas the blood reds recall the female body as well as our varying cultural readings of that color. Heesung's forms, while not easily readable, bring to mind feminine domestic arts like threadwork, crocheting, and braiding. Her work tests the limits of the physical qualities of paint, yet a narrative can be read through the colored strips. In sometimes deploying text from Korean and English newspapers, toppling them upside down, slicing them, and embedding them into the acrylic, thereby making them difficult or impossible to read, she references yet another predicament of the immigrant.

VAC: Heesung's work is manically obsessive. Think of the hours spent on these pieces. There is a determination here that reminds me of a comment made about post-World War II European artists. Surviving the devastations of war, to even make a mark was a belief in the future. I can't help but think that all of Heesung's strands or Lesley's threads as well as

Zarina's pin drawings or Wangechi's repeated act of chopping wood in her video *Cutting* engage in this faith. There is, as well, a commentary on the place of labor and production in art and international economies.

SP: Several countries in Asia and Africa depend substantially on their labor force, which is large and unwieldy but severely underpaid. I can see a subtle reference to menial/manual labor in *Cutting*, which we were discussing earlier. By projecting it very low on the wall, Wangechi invites us to cast our own shadows on the video plane in the hope that we might start to empathize with her "every woman." She also provokes us to look, think, and feel on other levels. It is timely, I think, with the war in Iraq that Wangechi's protagonist is filmed in Texas. This is a subtle but succinct comment on the deep distrust of that state's own political views and the US deployment of troops in regions of the world that never asked to be democratized. In her installation with dripping red wine bottles, the wine, like blood, starts to slowly leave a stain on the gallery floor, filling the room with a rancid smell. The work was originally titled *Hangin' in Texas* when Wangechi installed it in San Antonio last year. The use of common household objects like wine bottles to comment on a never-ending addiction to violence is reminiscent of Mona Hatoum's work *Vicious Circle* that was in the *Domestic Disturbance* exhibition that you referred to earlier.

VAC: I see the violence in both pieces as a reference to domestic abuse, fueled by alcohol. What interests me about Wangechi's protagonist in the video is the combination of strength verging on violence with a poignant vulnerability as she performs a repetitive, life-dulling task.

Adrienne Heinrich also references vulnerability in almost all of her work. She builds structures such as the ethereal *House of Souls*, casts figures and houses out of rubber, and constructs boats out of transparent paper or figures out of reeds. These materials, similar to those Lesley uses, are fragile yet flexible, and they allow us to see inside the figure or structure to what is normally invisible. The relationship between interior and exterior brings up the façade as a dividing line, which acts in much the same way as our own skin, tough and protective, yet penetrable. Adrienne's materials act and look like skin with delicate and porous borders. Her containers, frequently holding objects that hint of personal histories and cultural significance, evoke a visceral response, another commonality in this show. She attempts to penetrate to the core of our being, uncovering what is usually hidden and secret, what is invisible and ephemeral, and what remains just out of focus, haunting us in our attempt to understand ourselves and our world. She plays fear of the unknown and vulnerability against strength, suggesting a transcendent spirit with strong roots.

SP: What I enjoy about *House of Souls* is the symbolism of the home as a regenerative tool with wheat growing inside its translucent walls. Lit from within, it almost looks fairytale like, ablaze with fire. It seems as if nature has replaced the space usually reserved for human interaction, as Adrienne, in one installation of this piece, places the furniture that would have once belonged inside the house outside its boundaries on the gallery walls. She thus decontextualizes the domestic setting/structure of the house and creates a whole new narrative within its walls.

VAC: Adrienne's house glowing in a darkened room is almost the physical manifestation of Yuki Onodera's photographed houses. As Takaaki Morinaka said about her images, Yuki is a "materialist of light" who "bores directly into the existence of things, sometimes to retrieve their essence, other times to reveal what is absent."* That could apply to Zarina's "Home is a Foreign Place" as well. Zarina, Adrienne, and Yuki all hint at some kind of spirituality that resides within. The power in Zarina's house is in the recalled details, Adrienne might call hers a soul, and Yuki's might look like it has been invaded by aliens, but they all contain something mysterious, powerful, and intangible. The home is a central motif in Adrienne's work, and she has made many small houses out of cast rubber. The golden-colored structures contain objects that could be seen as figures of thinking that reveal unconscious feelings and memories associated with our dwellings.

The idea of the house as the site of the domestic woman has, of course, a long history. In the heady days of early feminism, Judy Chicago and Miriam Schapiro founded *Womanhouse* in Los Angeles as part of their feminist art program, designed to raise consciousness and provide the how-tos of becoming a serious artist. So many artists played in this house to rewrite iconography, creating brash work that demanded that we address questions about stereotypes and limitations, much like Helen Reddy would later sing: "I am woman, hear me roar." This was their safe house where they could work out their anger, hopes, and confusion. Adrienne's multi-faceted houses are part of this tradition. Of course they refer to the domestic, but they also relate to much more. In this show, for example, it will be interesting to see her white house near Rina's pink Taj as both colors

have certain connotations and the structures themselves contain loaded narratives.

SP: Their use of fabric is symbolic, and it also allows for osmosis to occur between the public and the private, urban and rural, man-made and natural. The need to reconsider these apparent dichotomies is another theme that runs through our exhibition and creates junctions for dialogue. I do think that what inherently ties many of these artists together is their interest in transformation in some manner, of either the impulse to move physically and hover between worlds, as you say, or the use of ideas and materials to break down, shift, or transform categories. These ultimately act as bridges across boundaries and lead to multiple ways of looking or thinking about life. Synapses or pulses firing in the brain lead us towards new associations and ideas; however, a breakdown of this communication can lead to the malfunctioning of the body. At a time of political strife, lingering gender issues, economic inconsistencies, and ethnic injustices in the world, the synapses firing in the exhibition are a small attempt at trying to find a common ground for understanding and expression.

VAC: ...and for making sense of the chaos. You often refer to dichotomies, but I feel that we have moved beyond those standard oppositions to a place of shifting nuances. I like to think that we are breaking through boundaries because it implies the osmosis you mentioned. The fact that you can see through the pink walls of the Taj and the amber walls of Adrienne's cast sculptures reinforces this idea of moving through.

SP: That's true. Adrienne's cast sculptures, with their embedded images and objects, recall the symbol of the body as the home and as the temple, a symbolism which is ancient and

potent and connects every atom and each cell with the macrocosm. The soul within the body, which serves as an architectural emblem, is strengthened by its aptitude for communication. Yet it is also cloistered due to veiling and the creation of a number of self-defensive sheathes around it. Some of these sheaths relate to the body itself, the mind, the ego, and the breath. Ultimately, these are both restrictive and protective like any other standard of identity such as gender, ethnicity, or nationality.

VAC: Yuki plays with these ideas in her life-sized "transvest" series. Here the body is seen in silhouette with only clothes and certain features such as glasses or spiked hair personalizing the figures. The body thus acts as a screen on which to project other aspects of the personality and as a place to negotiate encounters with one's environment.

SP: The figures in this series seem almost monumental in their ability to accommodate multiple images. However, they are anonymous at the same time as it is difficult in many instances to tell their age, ethnicity, or even gender. In this investigation into identity transformations, Yuki's work relates to Nina's experimentations in changing her own gender as well as the series "Animal Crossdressing" from 2002, where a snake and a rat were clothed in each other's skins. The transvests, in their ability to mutate and assume different personae, bring to mind Japanese male actors of the Kabuki theater tradition who easily assume female roles without ever really becoming woman. Their bodies are covered with superimposed images of capsized Moorish arches, aerial views of suburban houses, lush palm trees and lakes in idyllic settings, and airports seen from high above. Added to these are floating ladders, bullock carts harvesting land,

knights on horses, sprawling cities at night, inverted houses, a diver, skeletons in a Halloween parade, apartment windows, baroque churches, and tree-lined avenues. The images coalesce and overlap, creating a lattice-like patterning of fragile, yet tensile lace on the surface that is hard to disentangle. As many of the images are seen from odd angles and views, Yuki creates a multi-point perspective and pushes us in our attempt at understanding who these people might be. Portraits such as *Krio* and *Claude* are highly idiosyncratic and free-spirited and help us undergo a wondrous journey to try and follow the histories, stories, events, and circumstances molding their lives and personalities. In the end, we still have the freedom to come up with our own conclusions. Like the transvests, Yuki's houses are isolated against a monochrome background and literally float in space. Here again, we are left with no idea about context, of where these houses might be, who they belong to, or what might be taking place inside them.

VAC: Our lives unfold in our houses; they shelter us both physically and emotionally, and they contain traces of our conscious and subconscious lives. They can be seen as surrogates, objects on to which we project our memories and dreams, especially for artists who do not want to deal directly with the ideologically loaded body. Yuki's works are great examples of this projection as she creates a tangled web of information by infusing her portraits of houses and people with implied narratives. This multiplicity is again something all the artists suggest and something that they somehow order, participating in the process of map-making.

None of the artists in this exhibition would admit to searching for the meaning of life; it sounds too pretentious. But I think

that is exactly what they are doing in their work. Their ideas, approaches, and processes allow them to engage in active questioning. They are filtering ideas and feelings through their work, much like, for another metaphor, a computer program sorts, filters, and organizes masses of information. Or like our brains sort the daily intake while we sleep. Each individual's sense-making mechanism is different, and the artists in this show reveal their differences in their work. But there is a commonality between the ideas and the works. And I believe that commonality has to do with the search for how to make sense of our world and our place in it.

SP: Cheryl would agree with you for she has said that "post 9/11 we continue to negotiate our now uncertain identities through our purchases. Yet there is no allowance for the universalizing themes and unified views of globalization."* Relentless consumerism provides quick solutions. Cheryl satirizes this need with purses that are constructed of images of Prozac or women with reconstructed Botox faces and fringed totes with caricatures of overweight women. A boutique display adds a hysterical commentary on a post Kate Moss world.

VAC: She also points out that we frequently define ourselves by the things we buy and that we can deal with things more easily than feelings and changing conditions. I remember leaders saying that one way to deal with 9/11 was to shop in order to keep the economy going. Forget those who died, don't try to figure out why we are despised by so many, just go out and buy a new purse. Botox and Prozac are easy ways out. Barbara also deals with rampant consumerism in our culture in her latest series of drawings where funny little monsters, suggested with watery gouache, have overly

prominent mouths ready to devour meat, chicken, and the over-sized hamburgers of other drawings. I can imagine a group of them taking over a public place, racing around like wind-up toys. Like Cheryl's Botox and Prozac purses, they also refer to body issues affecting girls and women. Eating, in all its manifestations, sates and masks certain desires and needs.

SP: There is a tragi-comedy that plays out in Barbara's drawings, animation, and books, all of which are comical, absurdly funny, and poignantly critical. Surveillance cameras made of dripping black gouache point to the paranoia prevalent in society today whereas disembodied body parts that tweak and pull their own skins have to do with the fractioning and skewing of identity. Images of chunks of bloody meat that drip and stain the surface of the drawings are paralleled in the treatment of the grotesques, as Barbara refers to them, whose bodies also drip and sag under the weight of the watery gouache. They embody all that is wanton and debaucherous in our material needs and seem to revel unknowingly in their pursuits. Outstretched arms and scrawny fingers reach across space to get a slice of instant gratification. There is a disassociation between the body and our surroundings, brought on by unquenchable appetite. It brings us back almost full circle to our initial discussion about the McDonaldization of the world and the relentless transportation of mass culture, devoid of a necessary sensitivity towards the environment or local cultures. The flip side of globalization, however, is a dangerous kind of myopia or isolation supported by geographic and historic circumstances, which leads me back to 9/11. Although I was here in New York and can empathize with the event, I can't honestly put myself in your shoes as an American. Can you tell me a little bit more about your experience with 9/11 and its aftermath?

VAC: I didn't feel that affected at first by 9/11, but I began to notice a shift in this country, a desire for security, an interest in changing life patterns, a need to live life now and to the fullest. At the same time, our government started on a path of political and ideological insanity. These reactions to change are easiest for me to understand in terms of 9/11, but I feel that similar reactions have occurred throughout the world as politics and nature, such as the fall of communism and the tsunami, have irrevocably altered lives. I know of some of these shifts but am aware that there are many more that I do not know about. In the US, we know so much about Hitler's holocaust but so little of other mass genocides. Also, how many people, for example, know about the lost generation of children in South America and how DNA testing is being used to try to reunite children with their families?

SP: There are many examples. This sense of loss and ignorance permeates history and connects it with the present. India has witnessed many backlashes between the Hindus and Muslims ever since Partition more than 50 years ago, and several people in Zarina's generation found themselves in the crossfire, divided suddenly between two countries, unhinged from portions of their families. This predicament of displacement has been very prevalent in her work over the past five decades. In some instances, her discarded artworks are recycled to elucidate the constant stacking and restacking of immigrant lives. She salvages unfinished or discarded etchings to comment on how identity can follow bricolage; just as scraps of paper can be reconstituted into new forms, so can human life recondition and regenerate itself to create new foundations of stability and belonging. In *Tasbih*, she creates a continuous loop of 500 handmade sandalwood houses into one large communal

Muslim rosary cord. In a post 9/11 world, it seems timely that the artist raises the individual to a common platform of humanity and offers a larger symbol of faith across boundaries of geography, religion, and patriotism. The use of aromatic sandalwood also has associative characteristics and focuses us back into Zarina's childhood microcosm, where innocence lies.

VAC: I might not agree that childhood is the time of innocence, but Zarina's work is an excellent example of our desire to construct and reconstruct following postmodernism's deconstruction. *Tasbih*'s scented prayer beads speak across cultures even to the rosaries, bells, and smells of high Catholicism. These are, once again, figures of thinking, as the meaning evoked shifts from viewer to viewer and from installation to installation. If her sandalwood houses are arranged as a grid on the wall, they can look like a mandala, whereas if they freefall onto the floor, they resemble a coil of rope.

SP: Just as the sense of smell can lead to these kinds of evocations, memory too is a potent tool. Zarina's abstracted and distilled woodcuts are appropriate parallels to the traces that memory leaves on the subconscious mind. This gestural mapping of time and space with black ink on handmade paper is paralleled in the use of calligraphic Urdu—a language historically associated with poetics and spoken by Zarina with her family—below each image in "Home is a Foreign Place." As a language that is becoming outdated in several parts of the world, Zarina's archival sound recording of each Urdu word serves as a mantra, a sacred seed syllable that stirs up references and associations in the imagery and that sets the mood within each composition. Words like *chaukhat*/entrance, *sannatta*/stillness, *khushbu*/fragrance,

raasta/crossroad, and *manzil*/destination draw viewers into her world and help them along her itinerary of life.

VAC: The function of our figures of thinking is to lead to other ideas and memories or to help us find order or sense in our world. Historically, maps have played an important role in our organizing systems. There are, however, all kinds of maps, and many of them are not concrete or literal as seen in the work of Zarina, Adrienne, Nina, and Kathy. Zarina maps her childhood home both literally and figuratively, concretely and evocatively. In Adrienne's newest project, *Archives*, she starts with a handwritten document, an excerpt from personal or communal histories. It might be a property list or a family tree from a bible or even mathematical formulas from her husband's work. Each document serves as a map and is embedded in one half of a rubber cast panel. The other half features a geometric shape, organic form, a hand, or a key emerging from the panel. By marrying so-called fact with abstraction and symbols, and at times layering the found objects over the original texts, Adrienne plays with the notion of how we construct knowledge and perhaps implies that fact and fiction, ordering systems and abstraction are complementary not contradictory.

Sometimes maps are arbitrary; what happens when you cross a state line or a house straddles two counties or a tree grows on the border of two countries? Kathy is involved in an ongoing project of mapping major cities. Her sensitive pencil drawings float on white paper, giving the oddest sense of a city. Instead of showing just the streets on a map, she gives you the shape of the city. The problematic nature of geographic maps becomes crystal clear as those shapes seem to imply meaning.

Maps obviously move beyond the geographic. They become personal ordering systems by which we attempt to control or make sense of our world. Our mundane lives produce grocery lists and computer files while millions work to organize the information highway. I will never forget the scenes from *Diner* (1982) that focused on a couple's relationship when the young woman struggled to learn the idiosyncratic ordering system her fiancé used to organize his records. Mastering his method became a requirement for marriage, and their exchange became as much about personalities as a particular system. His insistence on her also knowing the songs on the flip side of his 45s reveals our belief not only in systems but also in facts. But anyone who has ever worked cataloguing books in a library knows the frustrations of attempting to stay within a logical, consistent system.

Nina has entered this territory with her photographs taken in personal libraries. After studying a particular collection, she groups books on their sides so that their titles read like sentences. By creating provocative or funny sentences that reflect upon the owner, she puts together a fantasy library. She reinforces that feeling by usually showing her images in a series so that they form a pseudo library on the wall, but when shown in a revolving slide show, her photographs offer flickering traces and memories, which form new ideas, partially based on what the viewer remembers. Books, a popular source of knowledge, become a site for interpretation and new, often arbitrary, meaning as Nina's rearrangements reflect hidden impulses, often with a sense of humor. They create a new order as Nina contributes a rereading of books which have often been considered dangerous and subversive in the larger culture.

SP: Nina's idiosyncratic book constructions range from history to playful humor, literary references to pop culture, novelistic love stories to political fervor, and poetic musings to filmic events. Her long-standing interest in using art to comment on "our culture's desire to keep things within their prescribed categories" relates intimately to Garber's figures of thinking and brings us back again to the basic conception of our exhibition. Like the artists in this show, our own belief in breaking down categories and not viewing individuals, cultures, or art on the basis of easy associations or definitions makes us walk a precarious tightrope.

I think that Mona would also agree with this approach. As a Palestinian who was forced into exile owing to political upheavals in Beirut, her work has been influenced by these circumstances. Her view of the world as one that constantly shifts below our feet is born from a sense of dislocation and nomadicism. However, as someone living in London since 1975, Mona admits that working within a Western institutional context has been an important factor in her work. She has also been influenced by theory and the abstracted, reductive forms of minimalism. Coupled with her irony and humor, she further prevents us from reading her work from the slant of ethnicity or identity. She says, "I'm often asked the same question: What in your work comes from your own culture? As if I have a recipe and I can actually isolate the Arab ingredient, the woman ingredient, the Palestinian ingredient. People often expect tidy definitions of otherness, as if identity is something fixed and easily definable."* This comes back to what I was saying earlier about certain artists from India who use these very definitions of otherness as their sole platform of expression.

Rather than seeing life in a linear or disconnected way, we believe in cycles—webs—links—nets—synapses—pulses—impulses—maps—whatever the visual metaphor of our philosophy might be. Throughout our discussions about our exhibition, you have always maintained the notion of trying to make sense of the world. While this might sound vague or ostentatious to some, it really boils down to a simple belief that a multitude of voices and a multiplicity of styles can lead to a more holistic or cohesive view of life, where convergences in contemporary cultures point to similarities in sensibilities and missions rather than only to the differences. In that art and feminism may also be considered as cultures, we have tried to create scenarios in which we are forced to think or look at these constructs in new ways and hope that audiences too will be able to bring their own viewpoints to the show with each new venue.

VAC: I believe that all of us are grown-up versions of little kids constantly asking why. Life becomes more interesting when we move beyond fixed answers and categories. We started by talking about certain ideas and artists that interested us. We both reacted, like Mona, to the use and misuse of categories that lead to a one-dimensional take on artists and works. In the process, we found a commonality among disparate practices, beliefs, and work. As we proceeded, our concept opened up, and even a Lombardi-like map or diagram seemed too limiting as we included work that suggested multiple responses and reactions. We found ourselves in new territory, which was difficult to explain in concrete terms, in a place where things have shifted but no new language has been invented to explain this paradigm shift.

In the process we have added our own insights based on our backgrounds and experiences. We definitely saw a commonality but never attempted to make the artists fit into any system or category. We tried not to make conclusive statements about the works we chose, something that is probably impossible to achieve. Rather we interpreted them from our own points of view; we even disagreed at times and realized that there are other possible explanations. What has emerged is a wonderful web of connections that hopefully enrich an understanding of the work, the artists, us, and even, perhaps, our world. I think that we found that factors such as race, gender, and religion interact in each person to form constantly shifting personalities that rise above such limiting labels, and that despite all the differences in the world, there are lots and lots of commonalities if we take the time to look for them.

Vicky A. Clark is an independent curator, writer, and professor living in Pittsburgh. Recent exhibitions include *Comic Release: Negotiating Identity for a New Generation*, *The Fact Show: conceptual art today*, and *Recycling Art History*.

Sandhini Poddar trained as an art historian in Indian and South East Asian aesthetics and antiquities in India, where she received her Masters degrees from Bombay University. In 2003, she received a Masters degree in Visual Arts Administration from New York University. She is currently working at the CUE Art Foundation in New York City.

selected reading

Roland Barthes, translated by Richard Howard, *Empire of Signs*, New York, Hill and Wang, 1982

Jorge Luis Borges, *Labyrinths: Selected Stories and Other Writings*, New York, New Dimensions, 1982

Brooklyn Museum, *Open House: Working in Brooklyn*, 2004

A.S. Byatt, *Possession*, New York, Vintage International, 1990

Centre Georges Pompidou, Musée national d'art moderne, *magiciens de la terre*, 1989

James Clifford, *Routes: Travel and Translation in the Late Twentieth Century*, Cambridge, MA, Harvard University Press, 1997

Samuel Dorsky Museum of Art, State University of New York at New Paltz, *Lesley Dill: A Ten Year Survey*, 2002, including "Tell It Slant" by Arlene Raven*

Marjorie Garber, *Symptoms of Culture*, New York, Routledge, 1998

Donna Haraway, "Teddy Bear Patriarchy," *Primate Visions: Gender, Race, and Nature in the World of Modern Science*, New York, Routledge, 1989

Dave Hickey, *The Invisible Dragon: Four Essays on Beauty*, Los Angeles, Art Issues Press, 1994

Irish Museum of Modern Art, *Kathy Prendergast: The End and the Beginning*, 1999

Merrily Kerr, "Cheryl Yun," *Art on Paper*, March/April 2005*

Krannert Art Museum, University of Illinois at Urbana-Champain, *Between East and West: Seven Transnational Artists*, 2004

Lamount Gallery at Phillips Exeter Academy, *Aliens in America, Others in the USA*, 2003

MASS MoCA and SITE Santa Fe, *Mona Hatoum: Domestic Disturbance*, 2000*

Mills College Art Museum, *Zarina: Mapping a Life*, 1991–2001, 2001

Museum of Modern Art, Gunma, Japan, *Yuki Onodera*, 1999, including "Optics that Impersonalize: The Art of Yuki Onodera" by Takaaki Morinaka*

Jeannette Winterson, *Art Objects: Essays on Ecstasy and Effrontery*, Canada, Vintage, 1996

checklist

Rina Banerjee

Born in Calcutta; lives and works in Brooklyn

Take Me, Take Me, Take Me to the Palace of Love, 2005
Mixed media installation
168 x 156 x 156 inches
Courtesy of Newman Popiashvili Gallery, New York City

When scenes travel...bubble, bubble, 2005
DVD projection with 3 stills; 6 minutes
Dimensions variable
Courtesy of Newman Popiashvili Gallery, New York City

Lesley Dill

Born in Bronxville; lives and works in Brooklyn

Language Extends Even to the Hair, 2003
Thread, copper, wire, and organza
144 x 168 inches
Courtesy of George Adams Gallery, New York City

Blonde Push, 2003
Wire, horsehair, thread, and tea stain
120 x 120 x 12 inches
Courtesy of George Adams Gallery, New York City

Ellen Gallagher

Born in Providence; lives and works in New York City and Rotterdam

Untitled, 2000
Lithograph on Tanbo paper; silkscreen on Okawara paper
13½ x 11 inches each
Courtesy of Hauser & Wirth, Zurich/London

Mona Hatoum

Palestinian born in Beirut; lives and works in London

Untitled (colander with stars), 2002
Japanese wax paper
15¾ x 21½ inches
Courtesy of Alexander and Bonin, New York City

Untitled (brain), 2003
Handmade paper
10¾ x 13 inches
Courtesy of Alexander and Bonin, New York City

Untitled (latin grater), 2001
Japanese wax paper
14½ x 18½ inches
Courtesy of Alexander and Bonin, New York City

Untitled (graters), 1999
Silver gelatin print
16 x 20 inches
Courtesy of Alexander and Bonin, New York City

Rubber Mat, 1996
Silicone rubber
1 x 23½ x 31¼ inches
Courtesy of Alexander and Bonin, New York City

Adrienne Heinrich
Born in Akron; lives and works in Pittsburgh

House of Souls, 2002
Fabric, rubbings, paint, wheat, and Styrofoam
104 x 84 x 60 inches

Archives, 2005
Mixed media
4 pieces, 12 x 12 x 2 inches each

Nina Katchadourian
Born in Stanford; lives and works in Brooklyn

Kinds of Love from "BookPace," 2002
C-print
12½ x 19 inches
Courtesy of the artist and Sara Meltzer Gallery, New York City

The Way It Is from "BookPace," 2002
C-print
12½ x 19 inches
Courtesy of the artist and Catharine Clark Gallery, San Francisco

Hamlet from "Composition," 1993
C-print
19 x 12½ inches
Collection of Stina and Herant Katchadourian

Dyslexia from "Reference," 1996
C-print
19 x 12½ inches
Courtesy of the artist and Sara Meltzer Gallery, New York City

Mended Spiderweb #14 (Spoon Patch), 144 strand patch, short, medium long, extra long pieces of Mölnlycke Tvättäkta #342 red thread reinforced with polyvinyl acetate adhesive glue, tweezers insertion technique, anchor lines reinforced by three pinecones and one spoon, 1998
Cibachrome
30 x 20 inches
Courtesy of the artist and Sara Meltzer Gallery, New York City

Marketing Tips for Spiders (39 alphanumeric characters, each ½ inch tall, constructed on Mölnlycke Tvättäkta #342 red thread and polyvinyl acetate adhesive glue, tweezers insertion technique), 1998
Cibachrome
30 x 20 inches
Courtesy of the artist and Catharine Clark Gallery, San Francisco

GIFT/GIFT, 1998
DVD, 10 minute loop
Courtesy of the artist and Sara Meltzer Gallery, New York City

Do-It-Yourself Spiderweb Repair Kit, 1998
Plexiglass box with scissors, tweezers, polyvinyl acetate adhesive glue, and Mölnlycke Tvättäkta #342 red thread cut to various lengths
8½ x 4½ x 1½ inches
Courtesy of the artist and Sara Meltzer Gallery, New York City

Simone Leigh
Born in Chicago; lives and works in Brooklyn

Mami Wata, 2001
Terracotta with steel armature
36 x 72 x 36 inches

Untitled #1 from "Hottentot Venus," 1995–99
Pit-fired terracotta with terra sigilatta
25 x 29 x 29 inches
Collection of Danny Simmons

Untitled #6 from "Hottentot Venus," 1995–99
Pit-fired terracotta with terra sigilatta
24 x 28 x 28 inches
Collection of A.O. Scott and Justine Henning

Untitled #9 from "Hottentot Venus," 1995–99
Pit-fired terracotta with terra sigilatta
25 x 24 x 24 inches
Collection of Andre Powe

Wangechi Mutu
Born in Nairobi; lives and works in Brooklyn

Cutting, 2004
DVD projection; 5:44 minutes
Color and stereo audio
Dimensions variable
Courtesy of Sikkema, Jenkins & Co., New York City

Untitled, 2005
Wire, glass bottles, and wine
Dimensions variable
Courtesy of Sikkema, Jenkins & Co., New York City

Untitled, 2005
Mixed media on Mylar
4 drawings, 22½ x 22½; 23½ x 22½; 21½ x 22¾; 22¼ x 22½ inches
Courtesy of Sikkema, Jenkins & Co., New York City

Yuki Onodera
Born in Tokyo; lives and works in Tokyo and Paris

Krio, 2003
Silver gelatin print
71⅜ x 50⅜ inches
Courtesy of JHB Gallery, New York City

Claude, 2003
Silver gelatin print
72 x 48 inches
Courtesy of JHB Gallery, New York City

Look Out the Window #3, 2000
Silver gelatin print
24 x 18 inches
Courtesy of JHB Gallery, New York City

Look Out the Window #9, 2000
Silver gelatin print
24 x 18 inches
Courtesy of JHB Gallery, New York City

Kathy Prendergast
Born in Dublin; lives and works in London

Secret Kiss, 1999
Knitted wool
12 x 16 x 6½ inches

Collection of the National Museum of Women in the Arts, Washington DC
Gift of the Heather and Tony Podesta Collection, Falls Church, VA

The End and the Beginning I, 1997
Cotton bonnet with human hair
1½ x 9 x 8 inches
Collection of Trish Bransten

The End and the Beginning II, 1997
Human hair and wooden spool
2¼ x 1½ x 1½ inches
Collection of the Arts Council of Ireland/An Chomhairle Ealaíon

Barbara Weissberger
Born New Brunswick, NJ; lives and works in Hoboken and Pittsburgh

#760, 2004
Gouache and ink on paper
22 x 30 inches
Courtesy of Capsule Gallery, New York City

#766, 2004
Gouache on paper
22 x 30 inches
Courtesy of Capsule Gallery, New York City

#804 from "The Story of Appetite," 2005
Gouache on paper
22 x 30 inches
Courtesy of Capsule Gallery, New York City

#810 from "The Story of Appetite," 2005
Gouache on paper
22 x 30 inches
Courtesy of Capsule Gallery, New York City

Untitled (flesh/mouth), 2004
Artist book with gouache drawings
4 x 11 inches
Courtesy of Capsule Gallery, New York City

Untitled (stretch), 2004
Artist book with gouache drawings
4 x 11 inches
Courtesy of Capsule Gallery, New York City

Heesung Yang
Born in Pusan; lives and works in New York City

Untitled, 2004
Acrylic on canvas
24 x 24 inches
Courtesy of Paradigm Art, New York City

Untitled, 2005
Acrylic on canvas
24 x 24 inches
Courtesy of Paradigm Art, New York City

Untitled, 2005
Acrylic on canvas
24 x 24 inches
Courtesy of Paradigm Art, New York City

Untitled, 2005
Mixed media on canvas
24 x 24 inches
Courtesy of Paradigm Art, New York City

Cheryl Yun
Born in Montclair; lives and works in Lafayette

Tac Suicide Vest with Matching Thong I from "The Cheryl Yun Collection Lingerie/Swimsuit Series," 2004
Former Iraqi soldiers demanding back pay and pensions confronted American soldiers yesterday in Baghdad, two Iraqi protesters were killed
Thursday, June 19, 2003
Black and white photo transfer on Gampi tissue
22 x 12 inches (Size 8)
Courtesy of JHB Gallery, New York City

Baby Doll with Suicide Panties from "The Cheryl Yun Collection Lingerie/Swimsuit Series," 2004
The bodies of 282 Bosnian Muslims massacred at Srebrencia await burial today
Friday, July 11, 2003
Black and white photo transfer on Gampi tissue
36 x 18 inches (Size 8)
Courtesy of JHB Gallery, New York City

Abstract One-Piece from "The Cheryl Yun Collection Lingerie/Swimsuit Series," 2003
Gampi Japanese tissue, and shrapnel
22 x 12 inches (Size 8)
Courtesy of JHB Gallery, New York City

Prozac Butterfly Baguette, 2002
Antidepressants lift clouds, but lose "Miracle Drug" label
June 30, 2002
Newspaper, Rives BFK, and wire
6 x 12 x 1 inches
Courtesy of JHB Gallery, New York City

Botox Purse with Beaded Handles, 2002
In Quest for Wrinkle-Free Future, Frown Becomes thing of the Past
February 7, 2002
Newspaper, Rives BFK, and wire
4 x 6 inches
Courtesy of JHB Gallery, New York City

Thigh Fringe Purse, 2003
Economic Scene: Employment and Prosperity Affect Body Inflation
September 26, 2002
Newspaper and Rives BFK
11 x 6 x 1½ inches
Courtesy of JHB Gallery, New York City

Zarina
Born in Aligarh; lives and works in New York City

"Home is a Foreign Place," 1999
36 woodcuts on handmade Indian paper mounted on Somerset paper and voice recording
16 x 13 inches each

Directions to My House, 2001
Ink on handmade Bhutanese paper
8½ x 6 inches

Tasbih (Prayer Beads), 2001
Sandalwood and leather cord
500 units, 1 x ⅜ x ½ inches each

All works are courtesy of the artist unless otherwise stated.

Rina Banerjee's *Take Me, Take Me, Take Me to the Palace of Love* was originally commissioned by MASS MoCA and SPNEA. The current version was commissioned by the Peabody Essex Museum which also lent the chair in the installation: *Prie-dieu Chair*; mid to late 19th century; Bombay Presidency; Blackwood; 35 x 20 x 25 inches. Collection of the Peabody Essex Museum; Gift of Miss Mary Silver Smith and Mrs. Usher P. Coolidge.

look feel think acceptance clichés immigrant taboos rural
individuality comment fiction fact consideration accents
associations ancestry question mimic subversion human
symbolism fear ownership superficiality surface provocative
interventions evaluate embeded equivocal collage fragility
possibilities distance interpretation avenues respect implicit
dialogues undercurrents sensibility definition communication
blurring disgust mirror evocative atmosphere conceptual
immersion control differentiation insight reactive destination
punctures slavery storytelling shifting piercing plastic scale
portrait refraction senses visceral appropriation appropriate
coexistence coherence conditioning consumerism multiple
contemporary space time dichotomies challenge boundaries
link information bridges surrealism satire humor tradition
oral happenings trade media quietude materials repetition
icons meditation norm safety nationalism violence narrative
allegory location offerings innocence culture immaterial
cycles unconscious death materiality ephemeral conscious
play identity life allusive illusive mask anonymity mutation
net figurative interventions absence dreams psychological
roles morphing translation place skin transformation local
literal nomads roots memory physical dislocation culture
representation commodification routes colonialism inclusion
mythology ethnic intuition travel sensuality religion universal
process theory assumption natural private politics border
testimony metaphor age perception migration stereotyping
convergences race tactile commonality maps displacement
everyday intimate associative systems urban village global
beauty experience hybrid change biography home nation
meditation diasporas faith text impulse feminine other
obsession future poetic territory choice body separation
webs pulse belief history spirituality freedom synapses

look feel think acceptance clichés immigrant taboos rural
individuality comment fiction fact consideration accents
associations ancestry question mimic subversion human
symbolism fear ownership superficiality surface provocative
interventions evaluate embedded equivocal collage fragility
possibilities distance interpretation avenues respect implicit
dialogues undercurrents sensibility definition communication
blurring disgust mirror evocative atmosphere conceptual
immersion control differentiation insight reactive destination
punctures slavery storytelling shifting piercing plastic scale
portrait refraction senses visceral appropriation appropriate
coexistence coherence conditioning consumerism multiple
contemporary space time dichotomies challenge boundaries
link information bridges surrealism satire humor tradition
oral happenings trade media quietude materials repetition
icons meditation norm safety nationalism violence narrative
allegory location offerings innocence culture immaterial
cycles unconscious death materiality ephemeral conscious
play identity life allusive illusive mask anonymity mutation
net figurative interventions absence dreams psychological
roles morphing translation place skin transformation local
literal nomads roots memory physical dislocation culture
representation commodification routes colonialism inclusion
mythology ethnic intuition travel sensuality religion universal
process theory assumption natural private politics border
testimony metaphor age perception migration stereotyping
convergences race tactile commonality maps displacement
everyday intimate associative systems urban village global
beauty experience hybrid change biography home nation
meditation diasporas faith text impulse feminine other
obsession future poetic territory choice body separation
webs pulse belief history spirituality freedom synapses

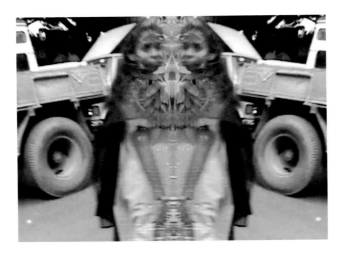

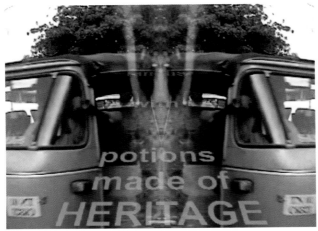

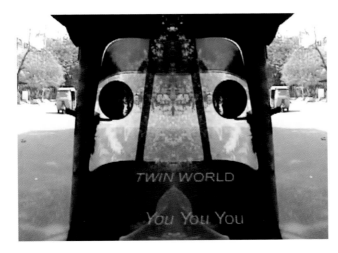

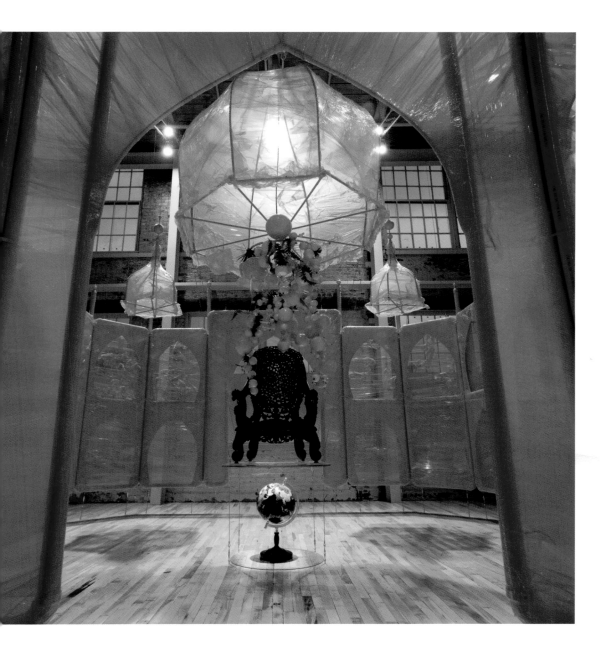

Rina Banerjee, *Take Me, Take Me, Take Me to the Palace of Love* (detail), 2003 *(above)*
When scenes travel…bubble, bubble (stills), 2005 *(opposite)*

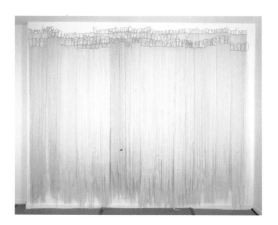

Lesley Dill, *Language Extends Even to the Hair*, 2003

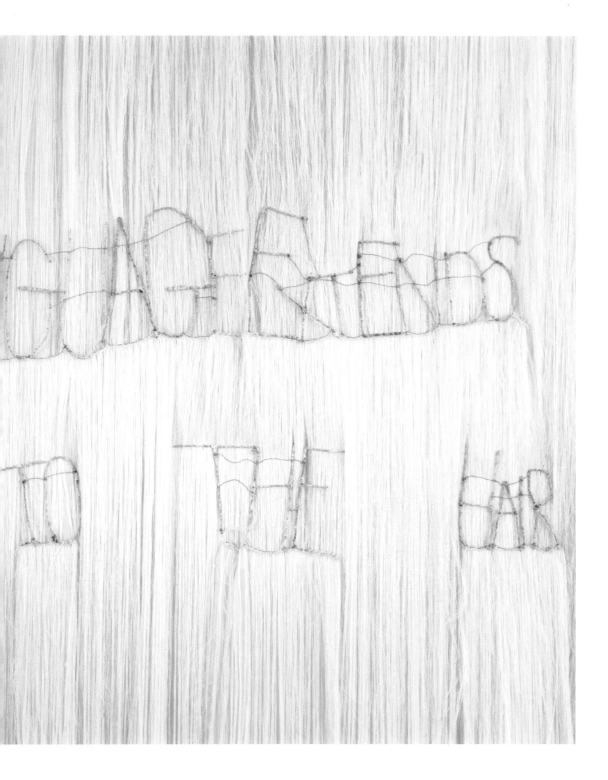

Ellen Gallagher, *Untitled*, 2000 *(above)*
Untitled, 2000 *(opposite)*

Mona Hatoum, *Untitled (latin grater)*, 2001 *(above)*
Untitled (graters), 1999 *(opposite)*

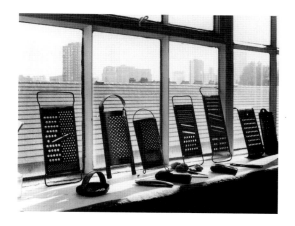

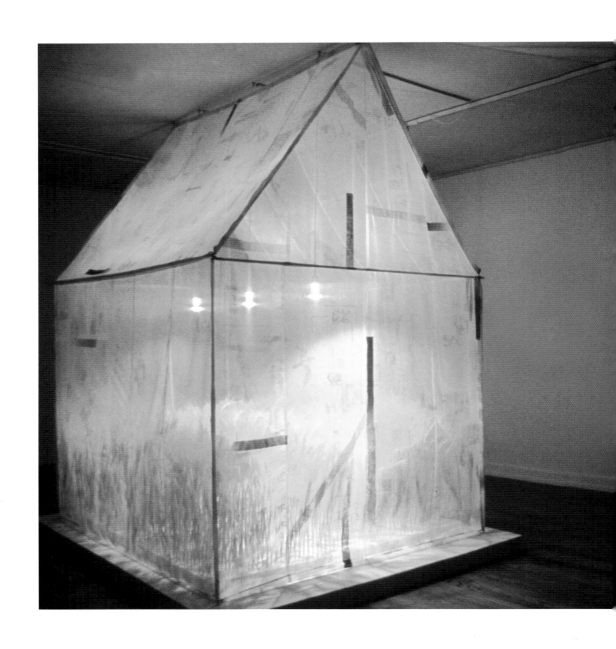

Adrienne Heinrich, *House of Souls*, 2002 *(above)*
Archives, 2005 *(opposite)*

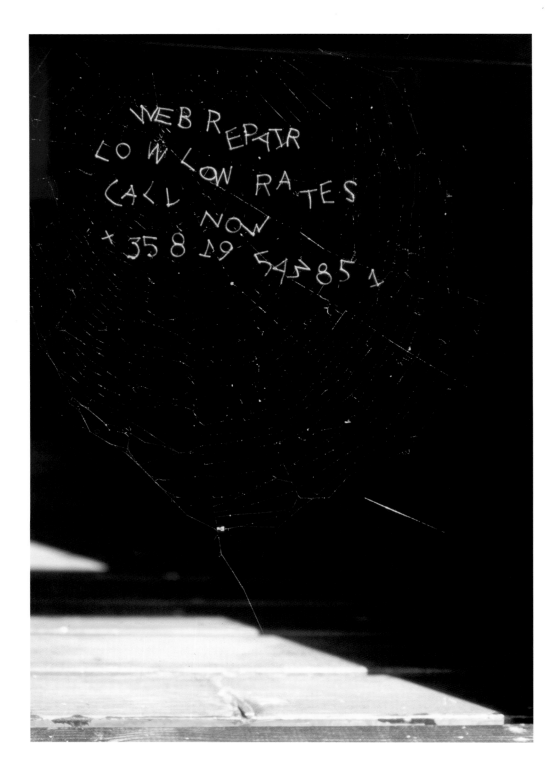

Nina Katchadourian, *The Way It Is* from "BookPace," 2002 *(above)*
Marketing Tips for Spiders (39 alphanumeric characters, each 1/2 inch tall,
constructed on Mölnlycke Tvättäkta #342 red thread and polyvinyl acetate
adhesive glue, tweezers insertion technique), 1998 *(opposite)*

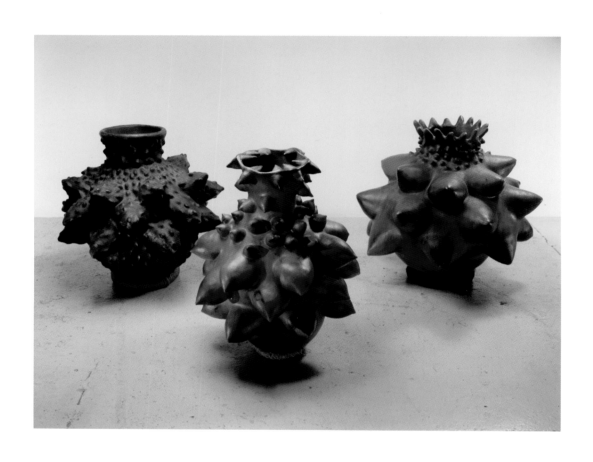

Simone Leigh, "Hottentot Venus" vessels, 1995–1999 *(above)*
Mami Wata, 2001 *(opposite)*

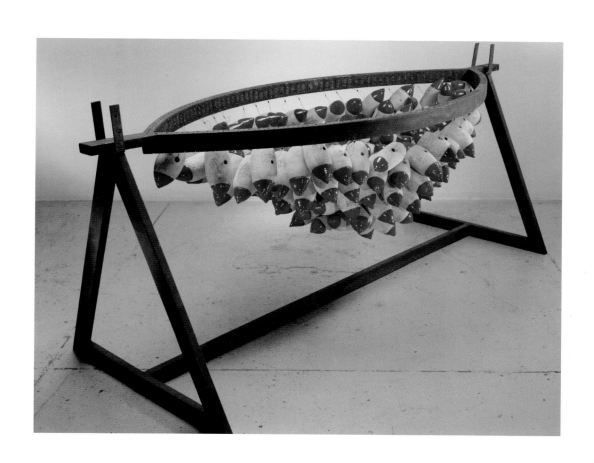

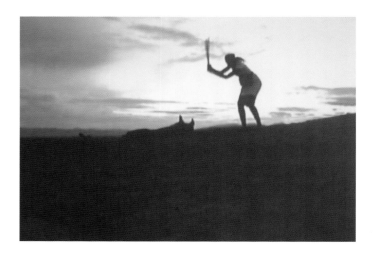

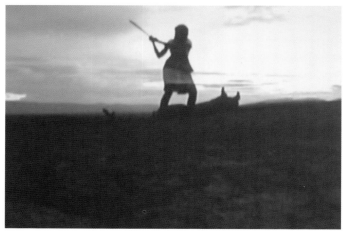

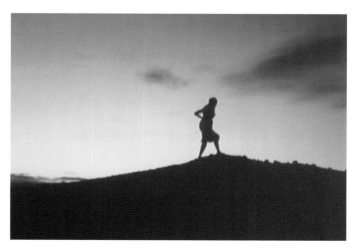

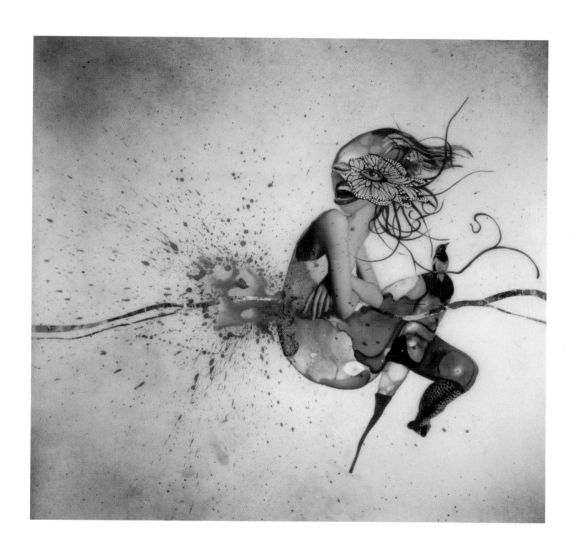

Wangechi Mutu, *Untitled*, 2005 *(above)*
Cutting (stills), 2004 *(opposite)*

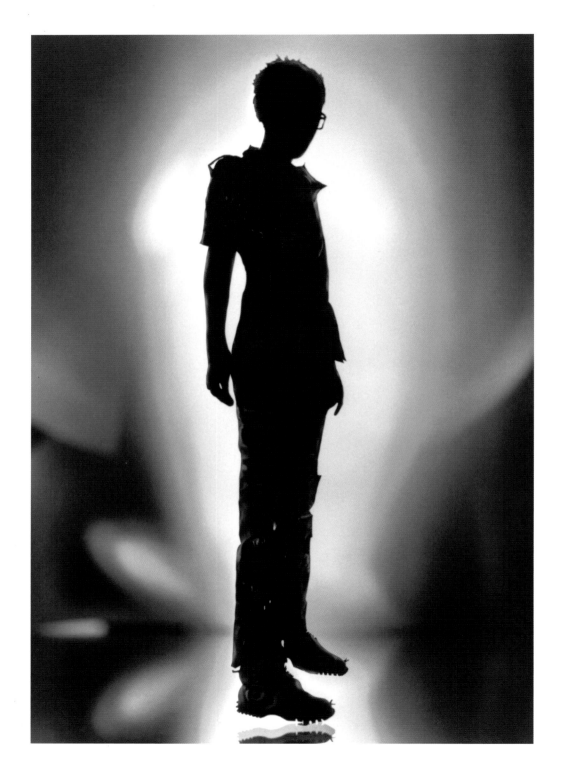

Yuki Onodera, *Krio*, 2003

Kathy Prendergast, *Secret Kiss,* 1999 *(above)*
The End and the Beginning II, 1997 *(opposite)*

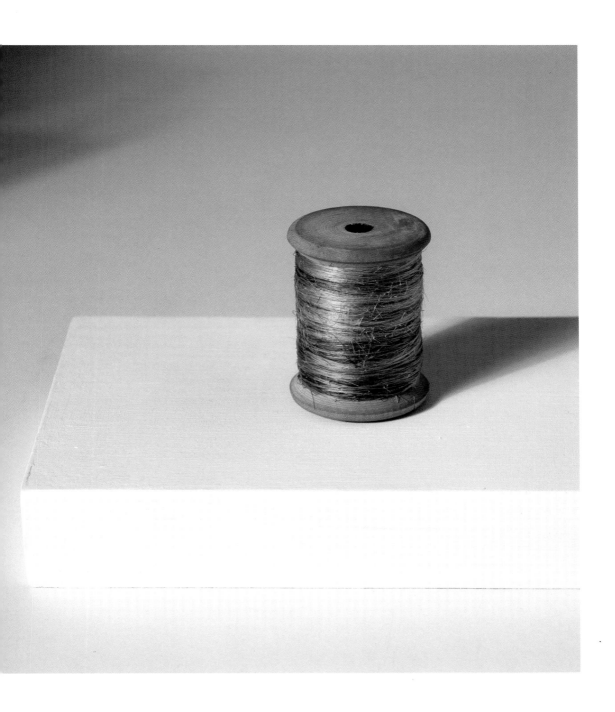

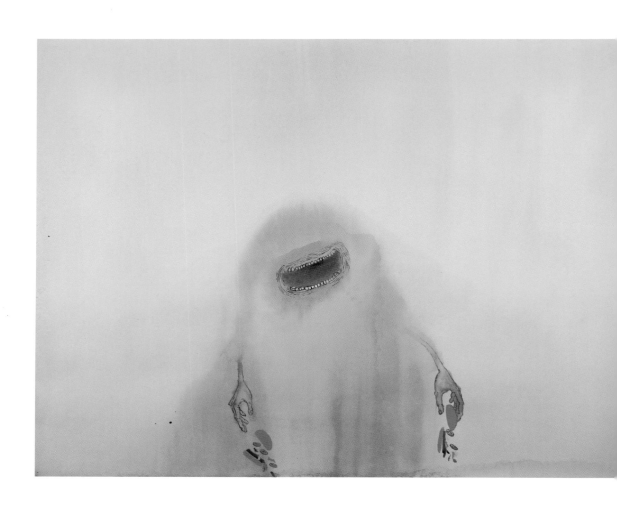

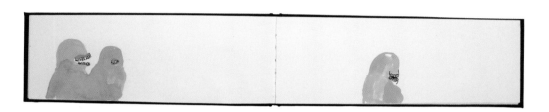

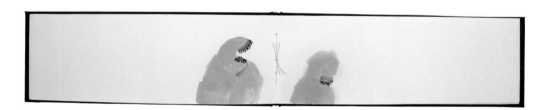

Barbara Weissberger, *Untitled (flesh/mouth)*, 2004 *(above)*
#810 from "The Story of Appetite," 2005 *(opposite)*

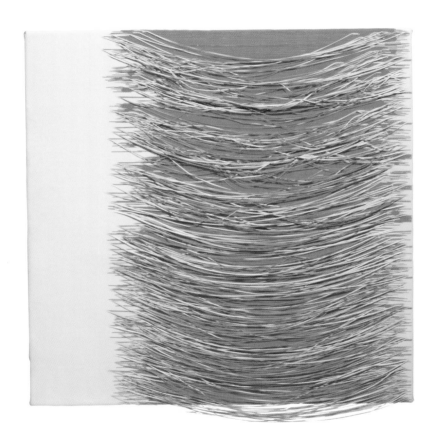

Heesung Yang, *Untitled*, 2005 *(above)*
Untitled, 2004 *(opposite)*

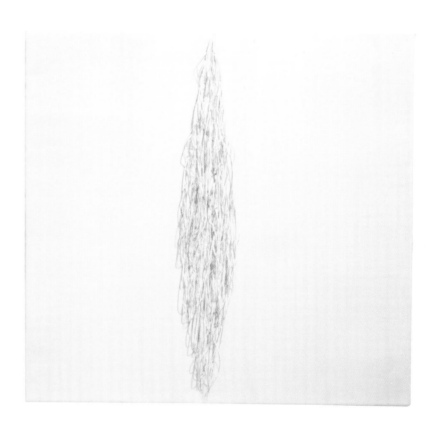

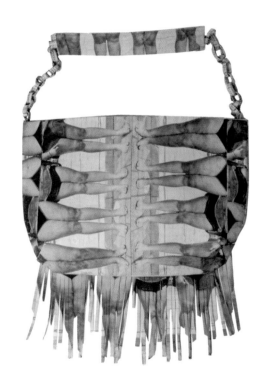

Cheryl Yun, *Thigh Fringe Purse*, 2003 *(above)*
Tac Suicide Vest with Matching Thong I from "The Cheryl Yun
Collection Lingerie/Swimsuit Series," 2004 *(opposite)*

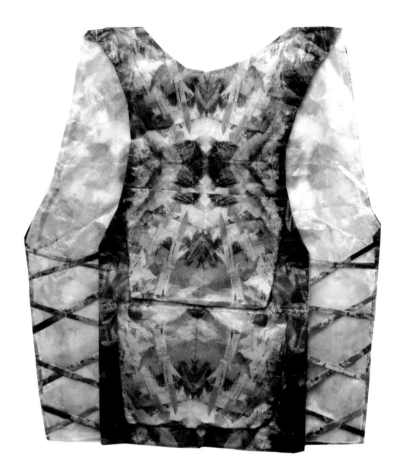

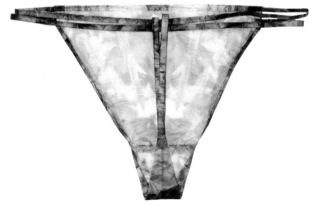

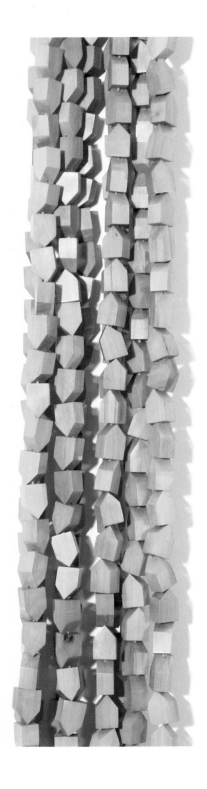

چوکھٹ

Zarina, *Entrance* from "Home is a Foreign Place," 1999 *(above)*
Tasbih (Prayer Beads), 2001 *(opposite)*

ISBN 0-295-98572-0

catalogue design by Brett Yasko, www.brettyasko.com
printed and bound in Pittsburgh by Kreider Printing

photo credits
Christopher Burke Studio: 88–89
Kevin Kennefick: 77
Ram Rahman: 102–103

co-published by
Pamela Auchincloss/Arts Management
338 W. 39th Street, 10th floor, New York, New York 10018
212 727 2845

University of Richmond Museums, University of Richmond
28 Westhampton Way, Richmond, Virginia 23173
804 289 8276

distributed by
University of Washington Press
Box 50096, Seattle, Washington 98145-5096
206 543 8870 www.washington.edu/uwpress